To Washington Park, With Love

To Washington Park, With Love

Photographs from the Summer of 1987

Rose Blouin

Haymarket Books
Chicago, Illinois

Published in 2024 by
Haymarket Books
P.O. Box 180165
Chicago, IL 60618
www.haymarketbooks.org

ISBN: 979-8-88890-098-7

Distributed to the trade in the US through Consortium Book Sales and Distribution (www.cbsd.com)
and internationally through Ingram Publisher Services International (www.ingramcontent.com).

This book was published with the generous support of Lannan Foundation,
Wallace Action Fund, and Marguerite Casey Foundation.

Special discounts are available for bulk purchases by organizations and institutions.
Please email info@haymarketbooks.org for more information.

Printed in Canada by union labor.

Library of Congress Cataloging-in-Publication data is available.

10 9 8 7 6 5 4 3 2 1

For Kimaada, Bakari, and Lotus Raine

Contents

Foreword ix
Adrienne Brown & Eve L. Ewing

It's Been a Long Journey 1
Rose Blouin

Soul Space 3
Angela Jackson

Landscape, Environment, and People Just Hangin' Out 5
The South Side People's Park: Landscape and
Environment in the Photography of Rose Blouin 6
Lee Bey

Sports & Special Events 37
Buoyed by Green Space and a Black Mayor:
Sports and Special Events in Washington Park 38
Salim Muwakkil

Art, Music, Culture, and Community 71
Happenings: Art, Music, Culture, and Community
in the Photography of Rose Blouin 72
Romi Crawford

Children & Families 105
Our Kingdoms to Come: Children and Families
in the Photography of Rose Blouin 106
Tracie D. Hall

Afterword: A Soft Beckoning Closer to a Black Sublime 137
zakkiyyah najeebah dumas-o'neal

Acknowledgments 140

Foreword

Adrienne Brown & Eve L. Ewing

Fun fact: the official motto of the City of Chicago is *urbs in horto*: "city in a garden." Even more fun fact: the official motto of the Chicago Park District is *hortus in urbe*: "garden in a city." An aerial view of the city makes it easy to see why. Greenery sprawls over the flat Midwestern landscape—in the privileged and moneyed corners of town, sure, but also across workaday neighborhoods and sites of struggle. The park is a place to gather, for children to seek some momentary independence, for a Sunday barbecue. And although Chicago has many glorious parks (and we are not at all biased, we assure you), when it comes to the history of Black Chicago social spaces, there is something distinct about Washington Park. Something special.

As Eve wrote in *Ghosts in the Schoolyard: Racism and School Closings on Chicago's South Side*, "So much of black life in Chicago happens in Washington Park that if you are African American, even if you are from the West Side or (like me) the North Side, it is hard not to find yourself there at least once each summer. The African Festival of the Arts, the Bud Billiken Parade, and family barbecues all find a home in the massive park. Sitting at the southern edge of Bronzeville, it covers 367 acres landscaped by Frederick Law Olmsted, the architect most famous for his design of New York City's Central Park."

But this storied site of Black gathering–and the many poses of Black leisure Rose Blouin's work gorgeously captures therein–turns out to be hard-won, the outcome of decades of struggle to simply be while Black. As Adrienne wrote in an essay on Washington Park, "Host to large, sprawling lawns and a series of scenic lagoons, this bucolic park was also a site of intense racial violence in the early twentieth century, as African Americans increasingly insisted on their right to this civic amenity." In his book, *Landscapes of Hope: Nature and the Great*

Adrienne Brown is an associate professor at the University of Chicago and author of *The Black Skyscraper: Architecture and the Perception of Race*. With Valerie Smith, Brown coedited the volume *Race and Real Estate*. Her most recent book is *The Residential is Racial: A Perceptual History of Mass Homeownership*. She serves as the faculty director of Arts + Public Life, fostering the arts on the South Side of Chicago.

Eve L. Ewing is the Chicago-born author of the books *Electric Arches, Ghosts in the Schoolyard: Racism and School Closings on Chicago's South Side, 1919,* and *Maya and the Robot,* as well as numerous other projects in nonfiction, comics, theater, and multimedia works. Ewing is an associate professor in the Department of Race, Diaspora, and Indigeneity at the University of Chicago

Migration in Chicago, Brian McCammack describes the violence Black Chicagoans risked when visiting the park in this period, acts perpetrated by white mobs claiming exclusive rights to the space.

Similar risks shadowed the Black Chicagoans who lived along the park's edges. Jesse Binga, founder of Chicago's first Black-owned bank, bought a home located on the southwestern edge of Washington Park that was bombed five times in 1919. And yet, Binga vowed to stay put just as other Black Chicagoans continued to picnic, orate, boat, and play sports in the park.

Black presence remains a matter of urgent importance in Washington Park today, if in different ways. Chicago's Black community has experienced massive depopulation over the past few decades at a level comparable to that of cities like New Orleans or Detroit, cities that have experienced notable disasters. These are cities indelibly shaped by Black people, Black presence, Black culture, now faced with once-iconic social gathering places that are either irrevocably transformed or gone altogether. The neighborhood of Washington Park (located directly to the west of the green space that shares its name) has become the poster child for Chicago's Black demographic decline: from a peak of 46,000 residents in 1970, it is currently home to under ten thousand. The verdant open land of Olmsted's park is now mirrored by vast amounts of open land to the west created under very different conditions: the demolition of the Robert Taylor Homes. When this complex (the largest public housing development in the country when it was built in 1962) was demolished in 2007, thousands of residents were displaced.

Amidst these disappearances, Rose Blouin's work is jaw-dropping; it transports us to a place that is familiar, in a time that feels at once intimate and distant. And it takes us to a moment of radical presence. Joy and conviviality. Serenity and solitude. Ambition and striving. Children and play and intergenerational relationships. They all leap forth from the photos in this book. More than simply filling us with longing or nostalgia for something that feels hard to recover, they challenge us to consider what was once possible, what remains, and what could be possible again, and to face our everyday gathering spaces with a keen new awareness and sense of gratitude.

If you go to Washington Park today, you can still see some of what Rose Blouin captured during that magical summer of 1987. There are barbeques and festivals galore–especially on a holiday weekend; fishermen still perch at the edge of the lagoon; baseball games are still played there on crisp spring afternoons; on the right day, you might even see Chicago cowboys on horseback trotting through the park. During the pandemic, the park was a haven for bird watchers and strollers discovering the parks' bounteous beauty for the first time. There is life in Washington Park yet. And there is Black life in Washington Park still. Blouin's lyrical images of Black repose urge us to relish moments of rest and splendor as both the ordinary fabric of Black life and sources of extraordinary beauty.

It's Been a Long Journey

Rose Blouin

In my seventh year as a self-taught photographer, I applied for my first grant from what was then the Chicago Office of Fine Arts' Community Arts Assistance Grants program. In later years, I would serve on the photography jury and become its chair, but writing that first grant proposal was challenging. I knew I wanted to do a documentary project and ruminated on the possibilities for some time. It wasn't until I attended an event in Washington Park, a place I had visited since childhood, that I knew I wanted to create a photographic documentation of the many community activities in Washington Park during the summer of 1987. The grant I received was small; just barely enough to cover the cost of film, chemistry, and photo paper. I had no idea, though, how much activity there would be to capture on film in Washington Park that summer.

It seemed my children and I *lived* in the park during the summer months. I knew right away that its varied landscapes were as important to my documentation as the people I photographed. It was a joyous time in a sprawling place where people gathered in droves to enjoy the great outdoors, music, recreation, arts and cultural events, festivals, sports, parades, and even weddings. I marveled at the masses of people, the small family gatherings, the solitary enjoyment of park spaces, and all the celebrations. Nearly every weekend, I wandered through the park looking for beauty, kinship, special moments, and images that reflected Black culture in infinite ways.

Throughout the summer, I diligently processed my film, made contact sheets, and stored negatives. After the summer, I returned to my job as a faculty member in the English Department at Columbia College, and my children returned to school. As a full-time single parent with a full-time job, I never found the time to print any images. My negatives and contact sheets remained stored in the basement for the next thirty-two years, except for the time my basement flooded. It took an overnight session to dry all the contact sheets with a hair dryer, and six weeks to clean and dry all the negatives. They returned to their large binder and to a basement shelf where they would remain until 2019, just a few years after my retirement from teaching.

The "Washington Park Project," as I called it, had always lived in my heart. I wanted to somehow bring it back to life, to see what this body of work held. The world of photography had transformed from film to digital, and I was inspired to write another grant application for funding which would allow me to have nearly 3,000 negatives scanned and converted to digital files. A generous grant from Chicago's Department of Cultural Affairs and Special Events (DCASE) made my dream come true.

Thirty-two years after 1987, I was finally able to see what I'd captured! It's difficult to express the joy I felt as I browsed through these black and white images on my computer. I was stunned by the breadth of my documentation, its historic importance, and its beautiful depictions of Black people, life, and culture, all in one summer, all in one place. One can pore over tiny images on a contact sheet, but they don't truly come to life until you view them on a 27" iMac!

After a year of organizing, several rounds of editing, printing and framing the images, the first exhibition of these photographs was mounted at the University of Chicago Arts + Public Life Arts Incubator Gallery, under the title *To Washington Park, With Love*. It was an appropriate title and, as Earth Wind & Fire would sing, "It's *all* about love": my love for my community, my culture, my people, and my art. Several other exhibitions, presentations, and lectures followed, and this project continues to be an ongoing endeavor.

I believe these photographic images capture the Black experience, and particularly our relationship to outdoor spaces and public parks. They remind us of times that were not without challenges, but that there continues to be a space for community gatherings, music, dance, and attention to social and political issues. My photographs depict loving families, beautiful children, caring communities, pride, and self-respect. I want my documentary images to affirm that Black Lives Matter and inspire viewers to imagine their own empowerment. I would like this work to be embraced as a celebration of Black life.

Photography is my gateway to timelessness. Whenever I photograph something, I am searching for that one moment which captures time, place, people and events that speak to me of the preciousness of life. While we can't relive the past, we can forever cherish what is captured in a photograph. My work always reflects the way I see the world; it's a personal vision, refined by introspection, seeking to connect the inner and outer expressions of life. For me, it's an ongoing dance of magic and creativity. It's taken thirty-seven years to birth this book. Embrace, herein, the magic of 1987 Washington Park as the people's sanctuary.

Soul Space

Angela Jackson, Illinois Poet Laureate

The sky vivid color and we would walk on it, and
dance and shout and give a holler, for
the summer made sense in that holy place
where trees were great sturdy clouds and you could
climb the bark to the fluffy limbs and laugh.
Washington Park was always Washington Park,
a resplendent place for us because it was for us, awesome,
and we were and are a gathering of souls in a soul space
named first for a president who owned us but we never thought of
but renamed for a mayor we chose
Harold Washington made sense Washington Park.
Right on Right on.
And each August parade ended there
the joy culminated where
the parade of our history and our future possibilities
danced the boulevard.

Open meadows are ours, courts of many brown-black colors
all shades of African Diaspora hallelujah people.

Angela Jackson, the fifth Illinois Poet Laureate, has won numerous awards for her work as a poet, novelist, and playwright, including the American Book Award. Jackson has been a member of the Organization of Black American Culture, a community that fosters the intellectual development of Black creators, since 1970. She has held teaching positions at Kennedy-King College, Columbia College Chicago, Framingham State University, and Howard University.

Landscape, Environment, and People Just Hangin' Out

The South Side People's Park

Landscape and Environment in the Photography of Rose Blouin

Lee Bey

There is a pervasive lie that's frequently told about Washington Park: nobody uses it. It's an untruth usually told by outsiders who want to use the park's 372 glorious acres for something new, be it space for the 2016 Summer Olympics—thank goodness that bid failed, in 2009—or for a certain $800 million presidential center that ended up in neighboring Jackson Park. But this chapter's photographs show Black folk in the summer of 1987 making good use of Washington Park, from kids exploring a lagoon to large groups relaxing in the grass.

Ah, the summer of 1987. What a time it was, beautifully reflected in these slices of life captured by Rose Blouin. Harold Washington, the city's first Black mayor, had been elected a few months earlier to what would become a tragically shortened second term. And for many Black Chicagoans, there seemed to be an added measure of joy, as reflected in Blouin's images: it finally began to feel as if the city belonged to us, too.

A fit, mustachioed brother poses with his bicycle in one image, taken on the park's great lawns. Beautiful in their own right, the green expanses also serve as gathering spaces for civic events, reunions, and the like.

For children, Washington Park was a magical place of adventure. A photograph shows a child who looks as if she's finishing some serious play in a rocket-shaped slide on Bynum Island, a quiet landmass that is among the park's best features. The island, encircled by the park's lagoon, is named after businessman Marshall Bynum, the first Black member of the Chicago Park District board.

Meanwhile, in another image, a group of boys is captured at the park's lagoon. Surrounded by greenery and nature, they look as if they could be in some remote rural spot instead of a city park just eight short miles from downtown Chicago.

Blouin has documented the boys and everyone else in this book using Washington Park as it was intended. The massive South Side green spot was designed in 1871 as a pastoral getaway, with meadows and a gently rolling landscape, in the middle of a bustling and rapidly growing Chicago. Designing

Lee Bey is architecture critic for the *Chicago Sun-Times* and the author of *Southern Exposure: The Overlooked Architecture of Chicago's South Side*. Bey's reporting and photography have been featured in the *Houston Chronicle*, *Crain's Chicago Business*, *WBEZ Chicago*, *Chicago Architect*, *Old House Journal*, *Cite* magazine, *Bauwelt*, and *Modulør*.

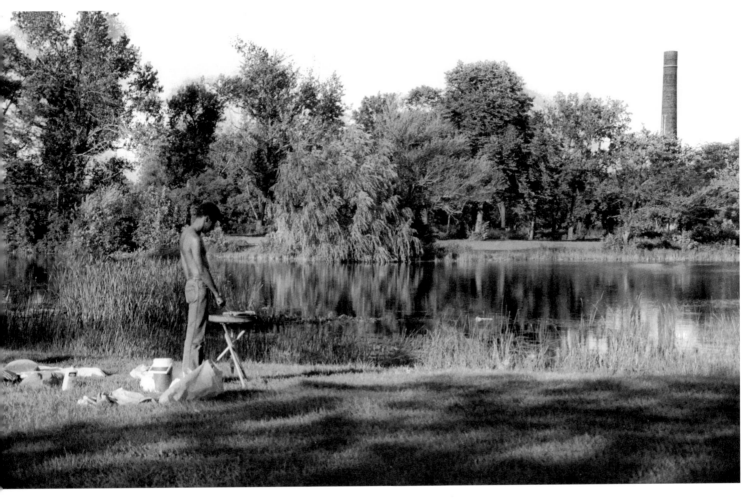

for the Victorian set, the park's framers gave the locale a conservatory (since demolished) and what were once flower-lined, strolling paths. Black people, who began moving into the area in significant numbers in the 1940s, have made it a far more active and alive park as these images show.

The beauty of Washington Park, in addition to its design, is that it's an open, free, and public space for the people, and the important story Blouin tells in this chapter and with this book only reinforces that truth.

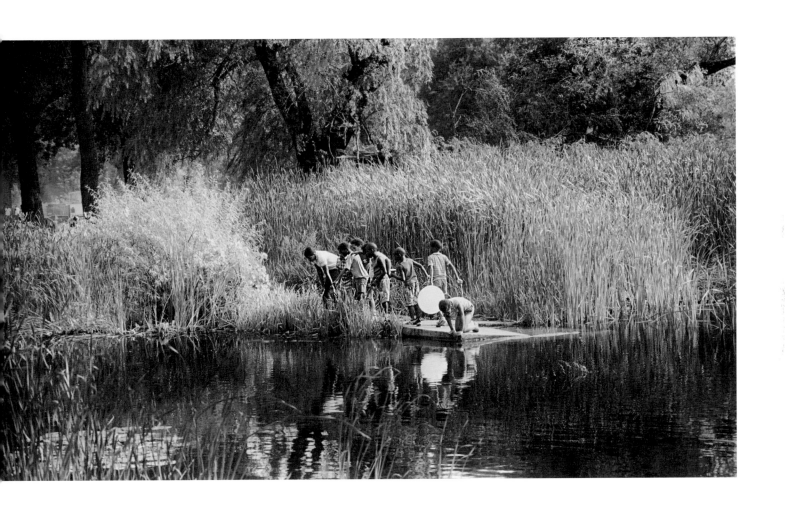

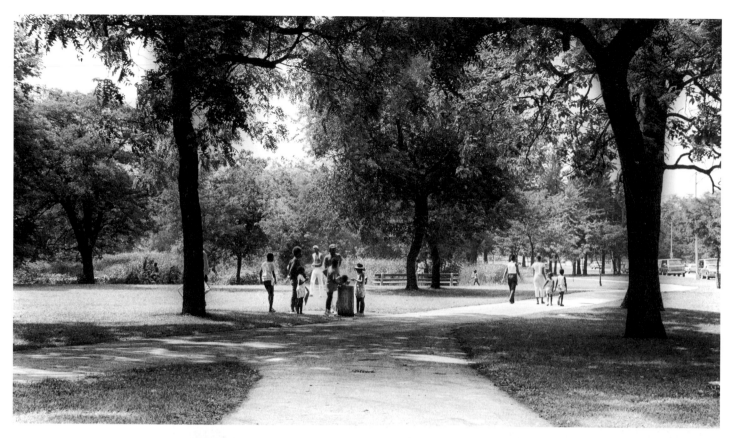

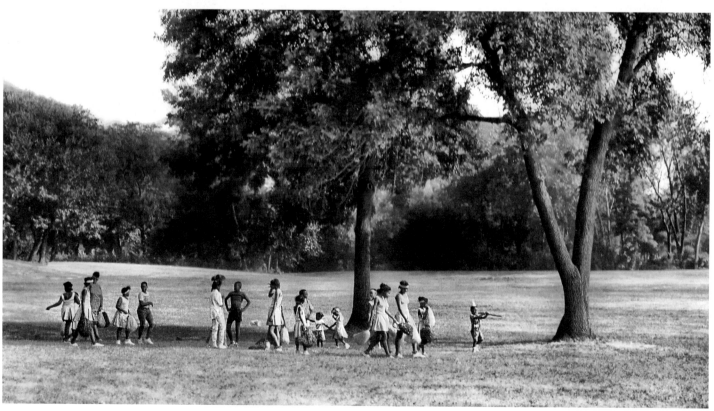

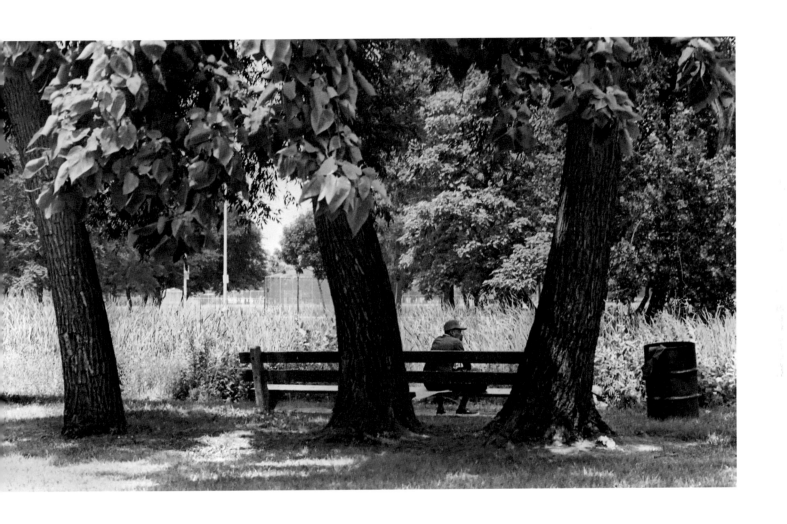

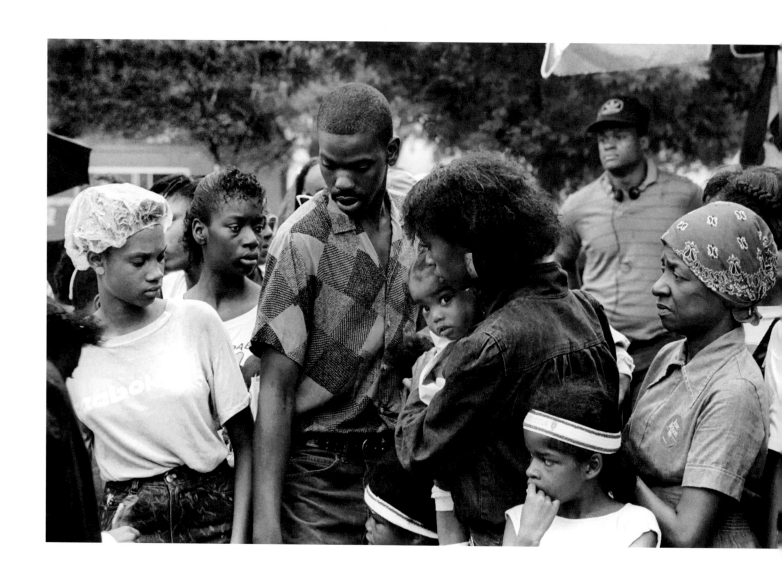

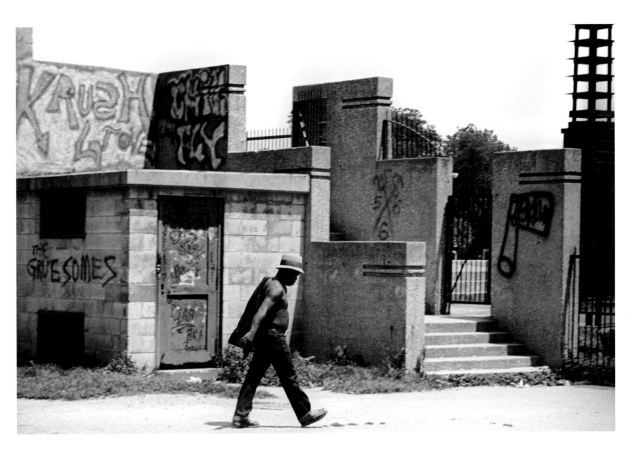

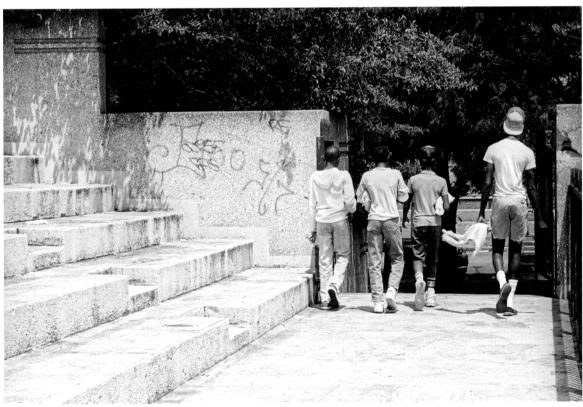

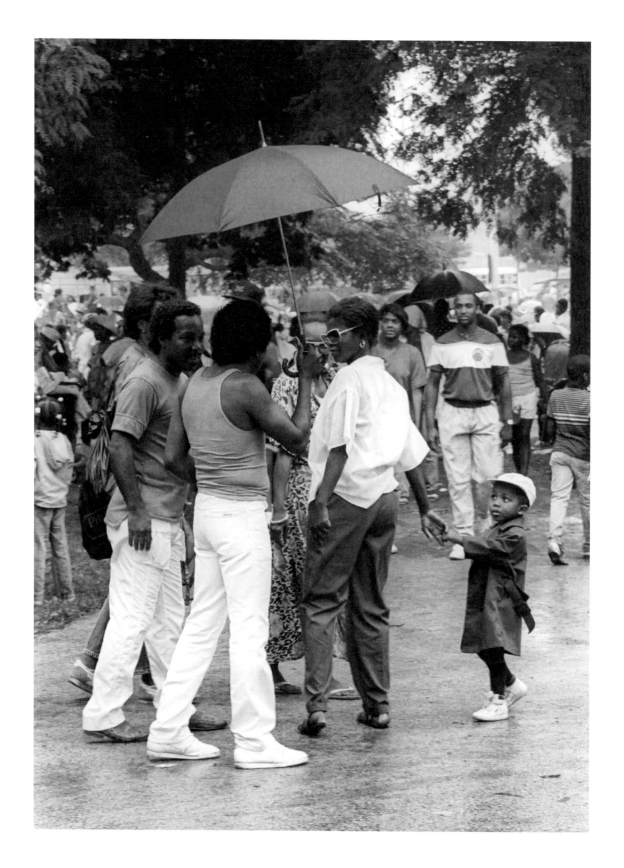

14

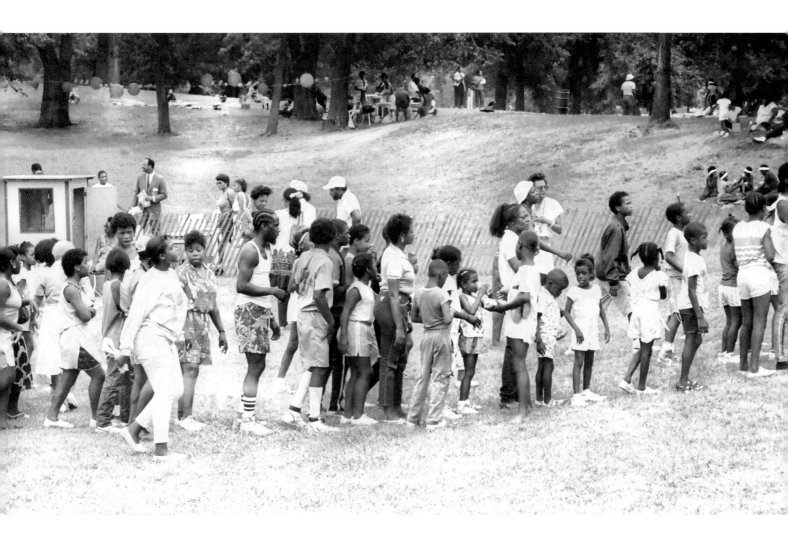

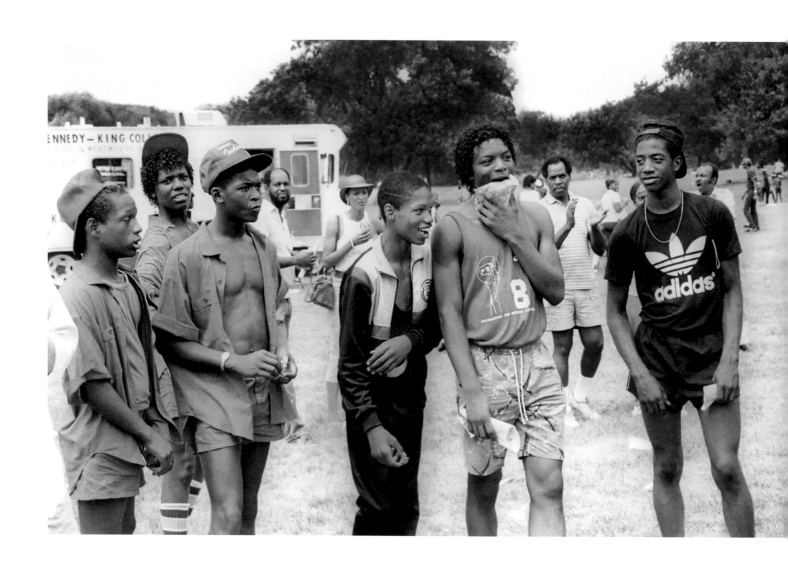

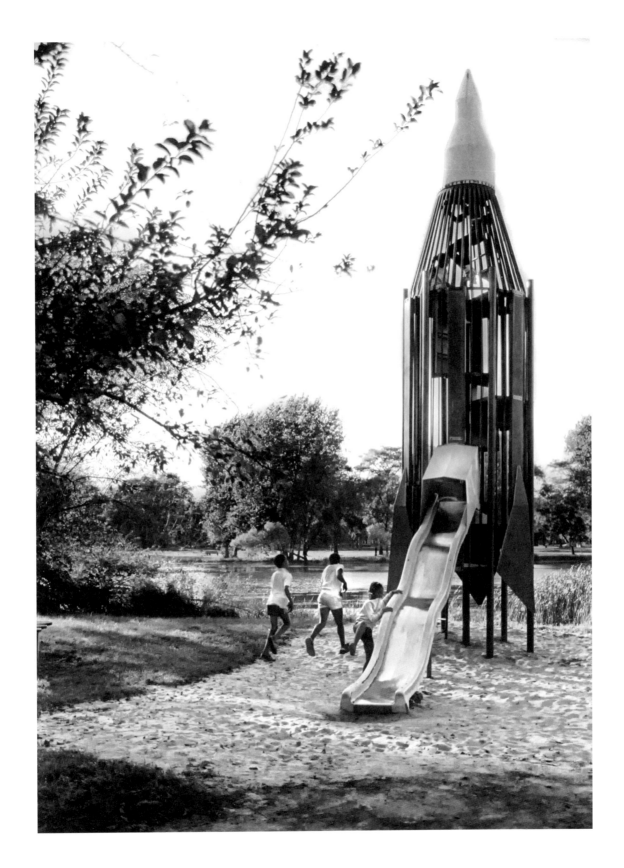

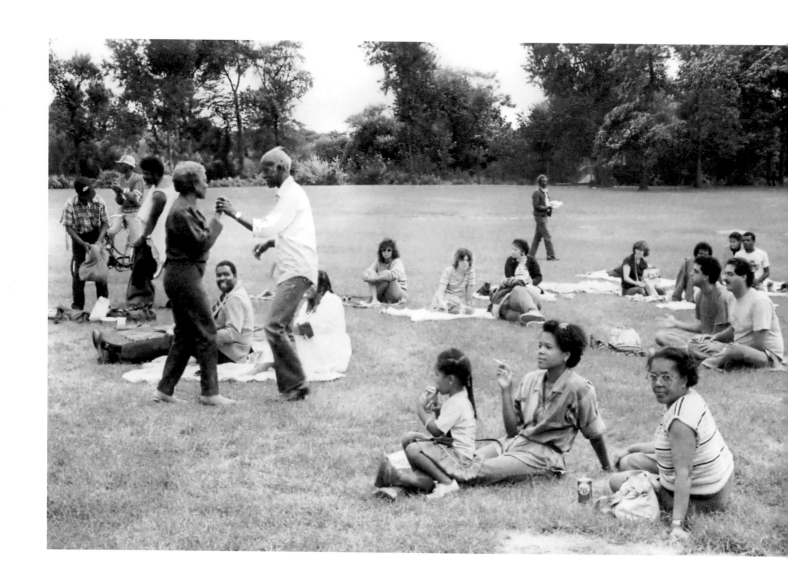

18

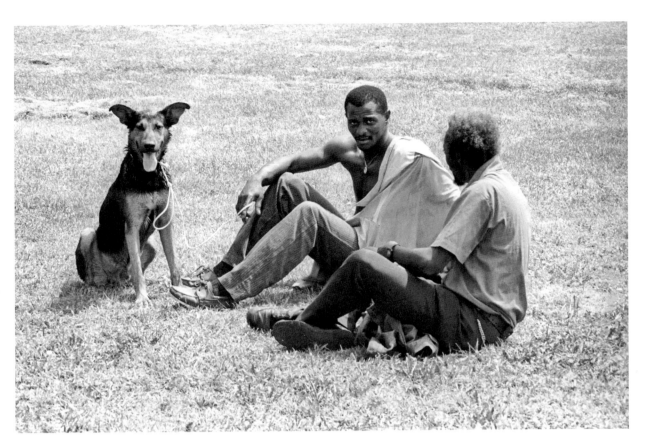

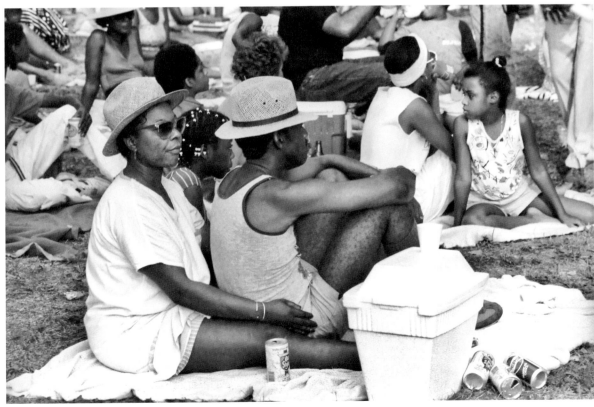

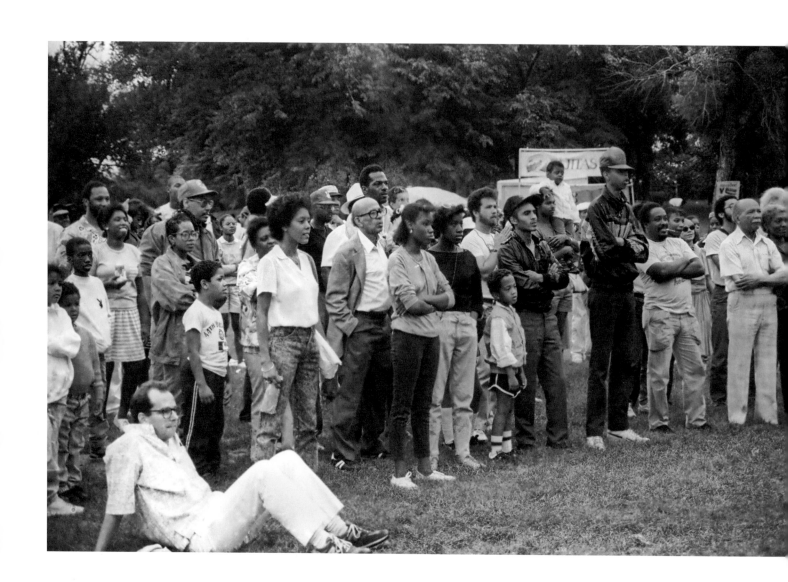

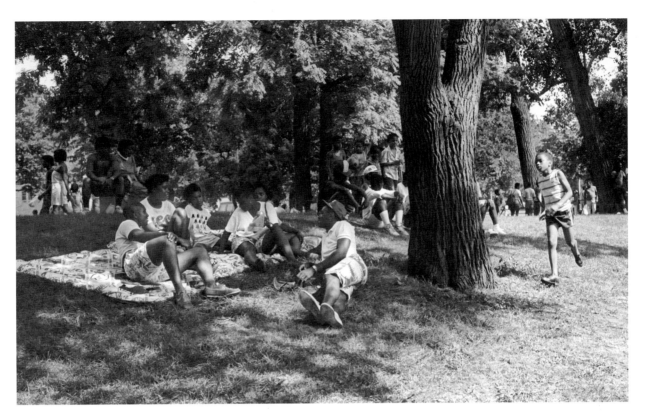

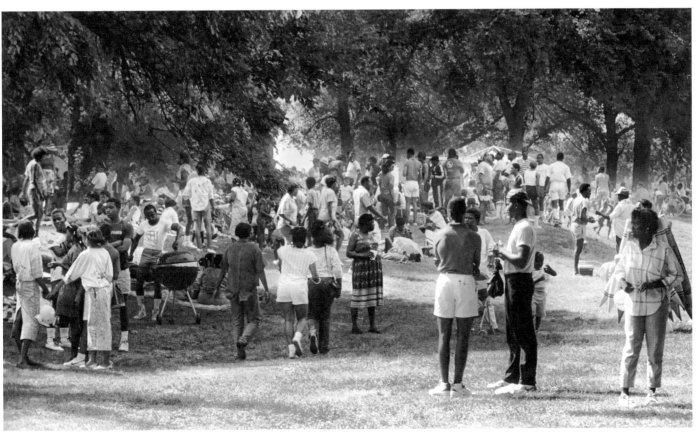

21

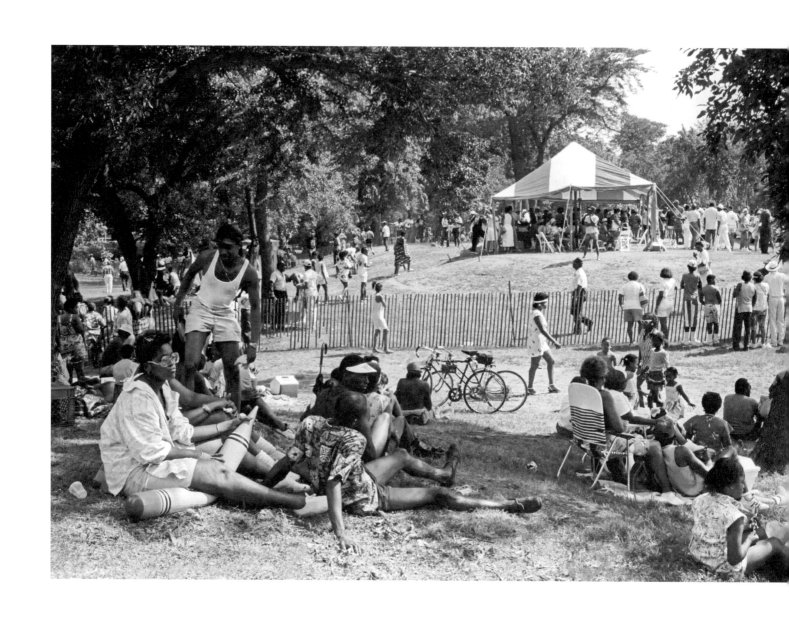

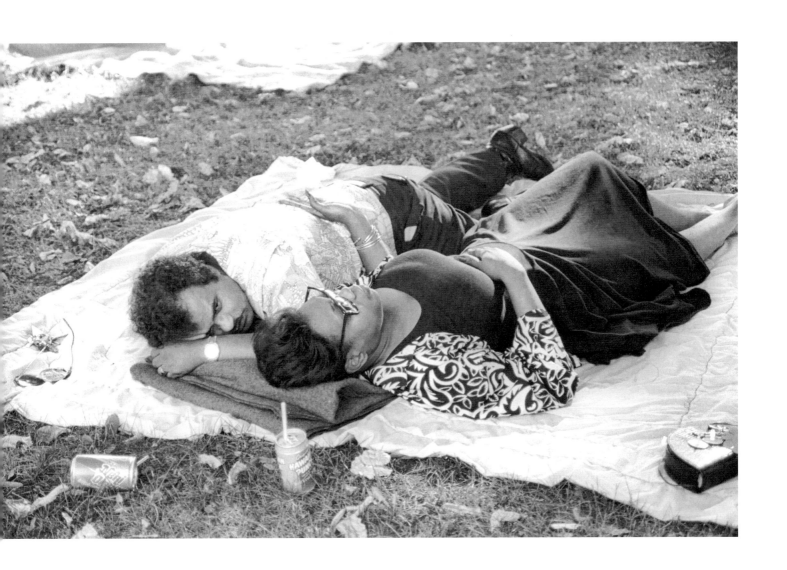

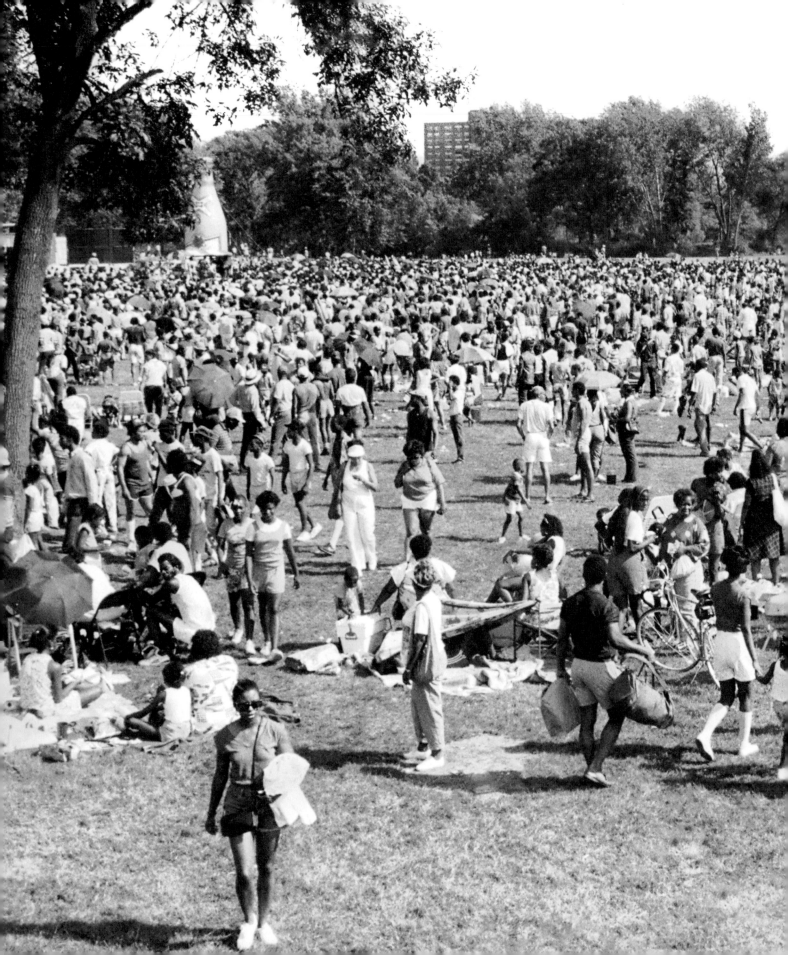

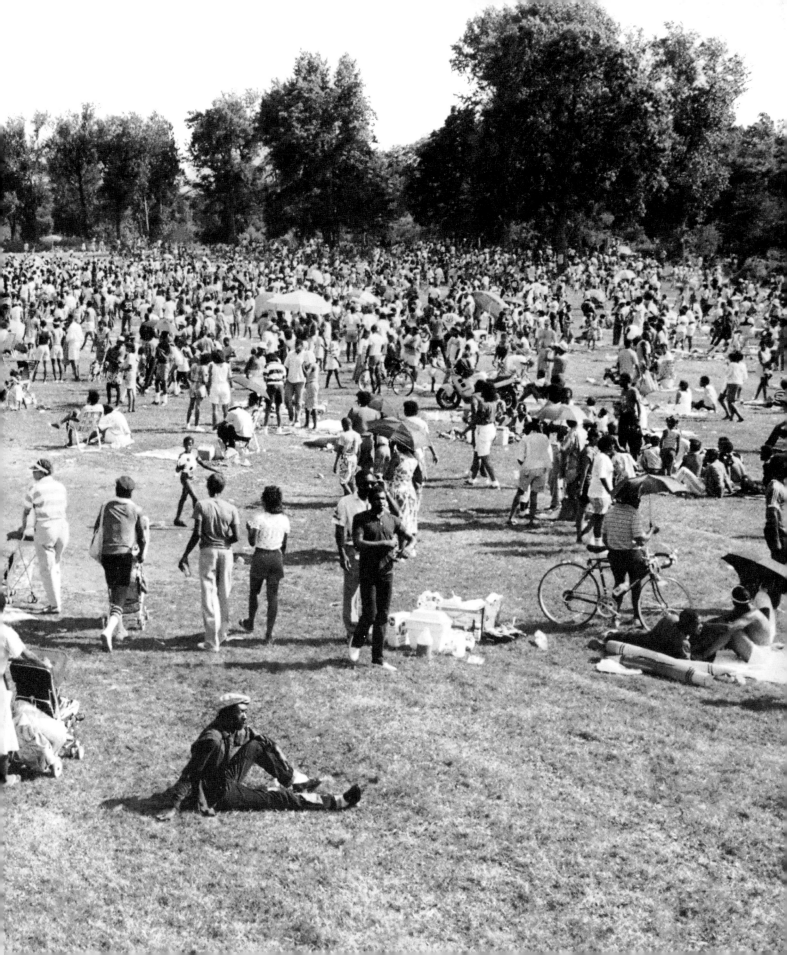

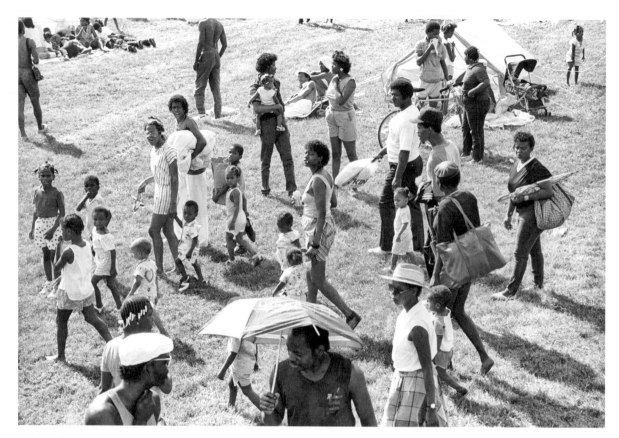

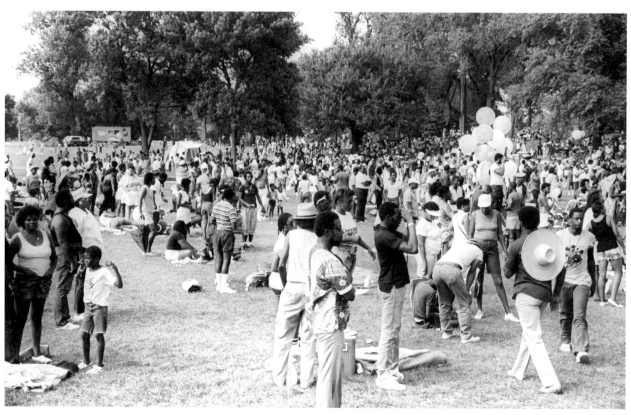

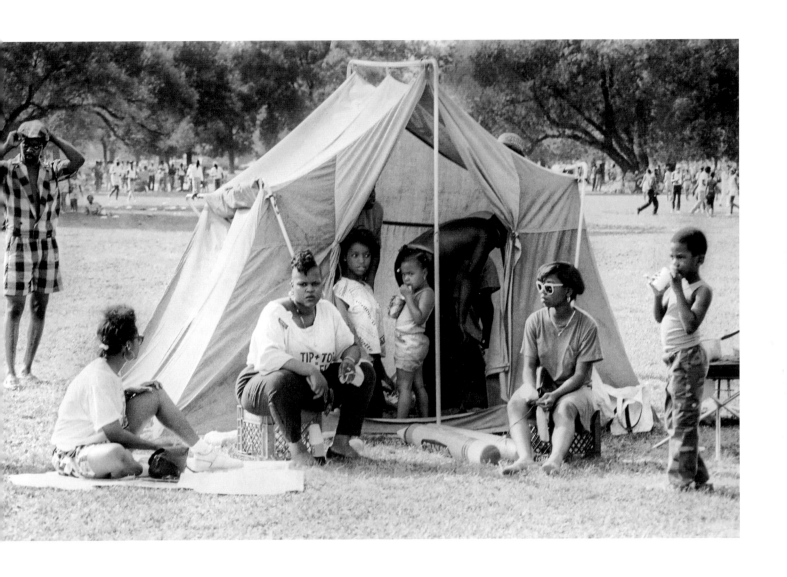

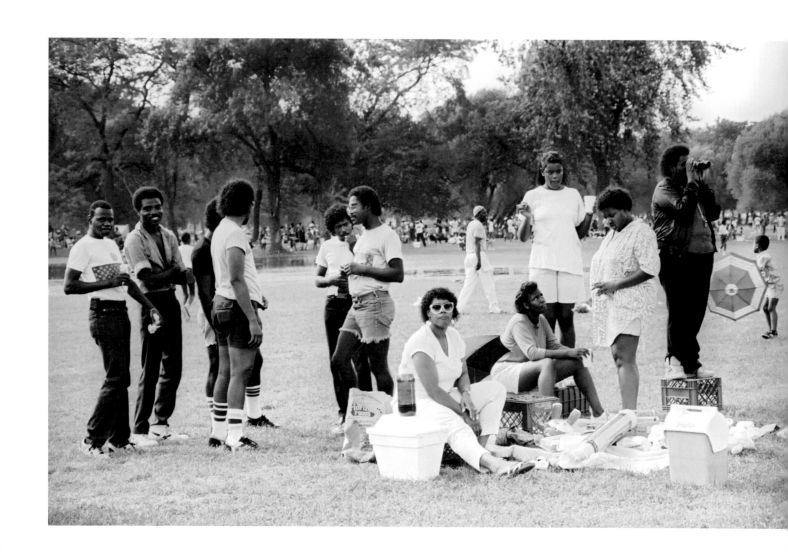

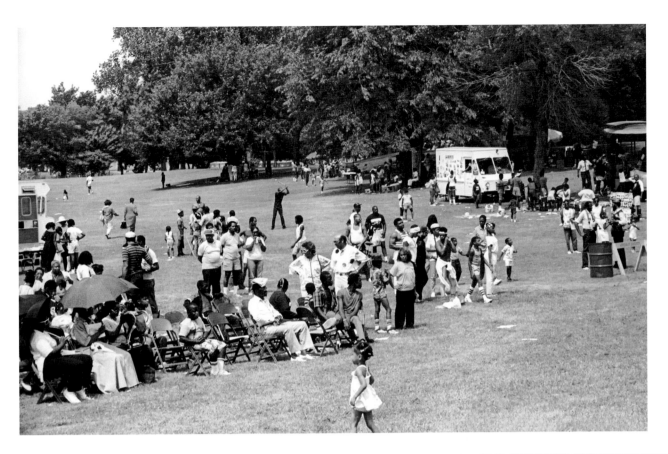

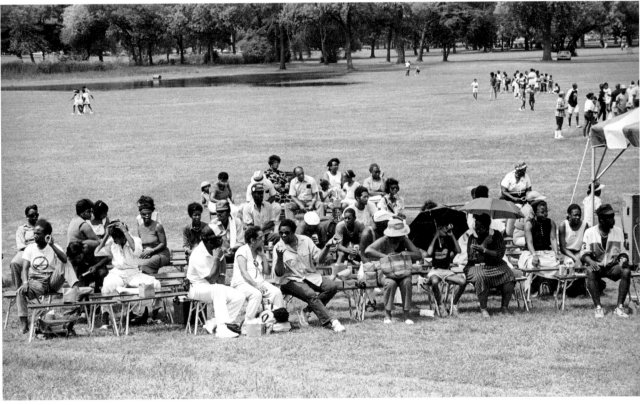

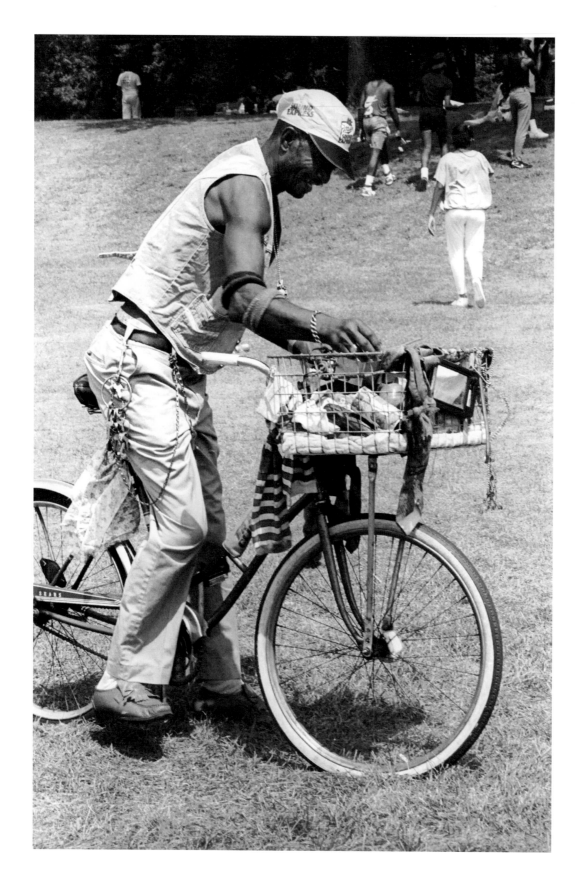

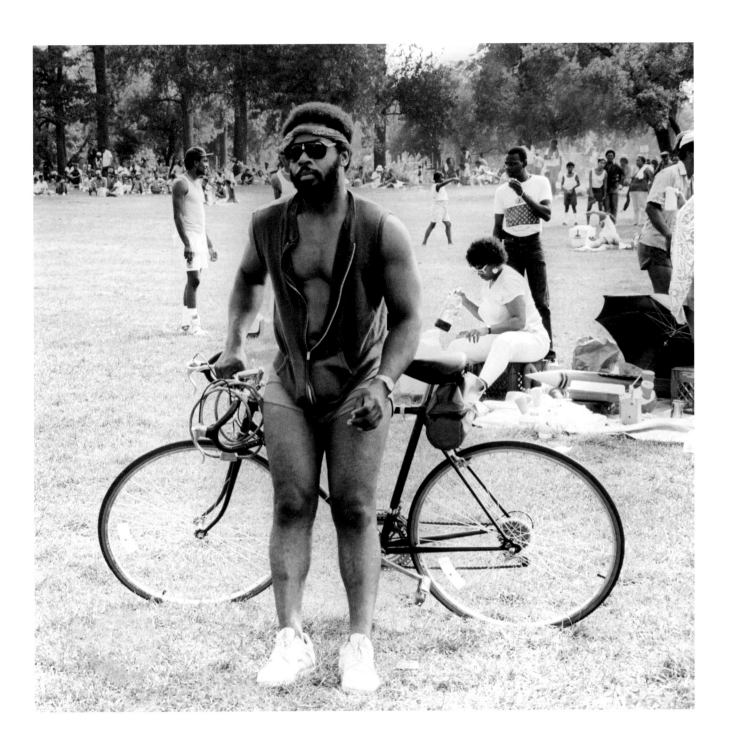

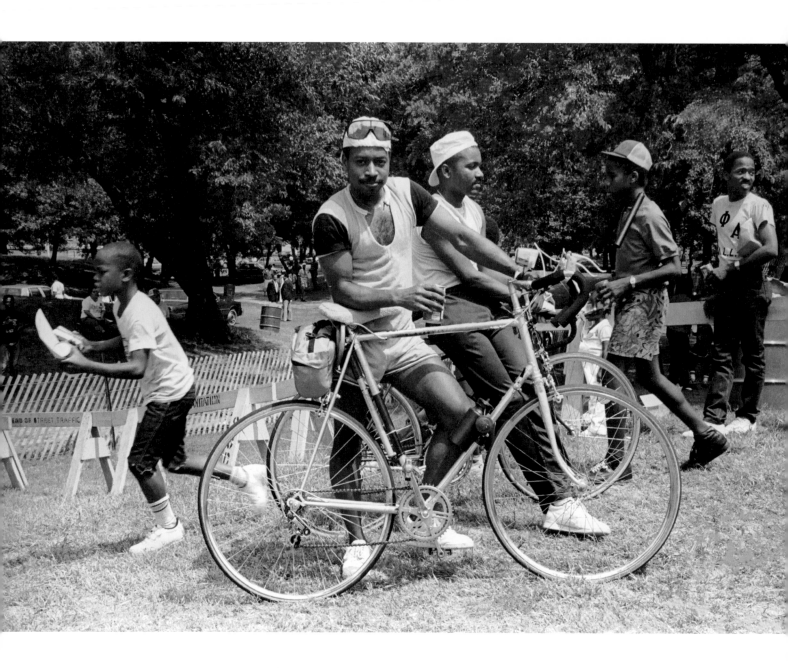

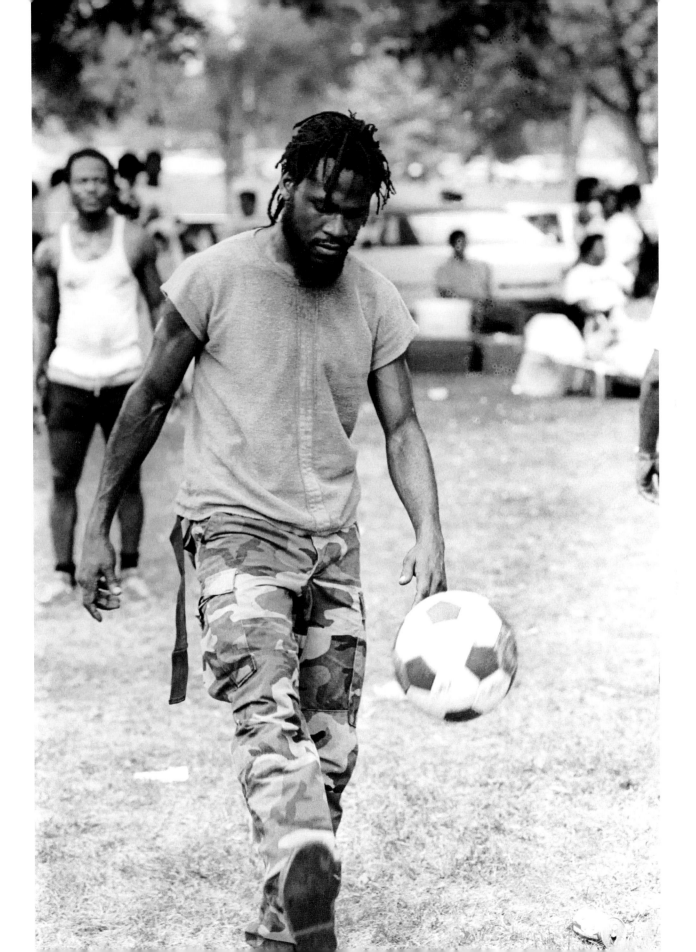

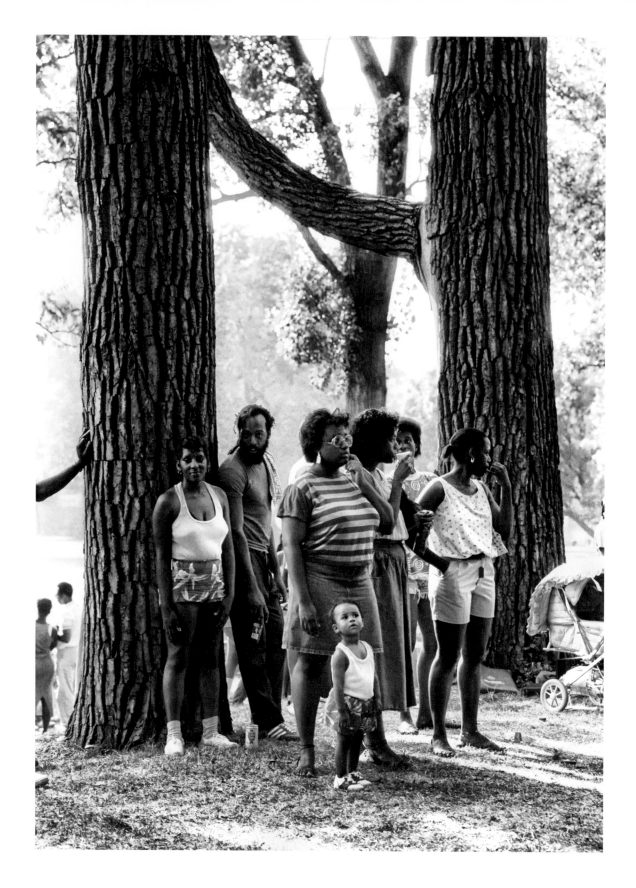

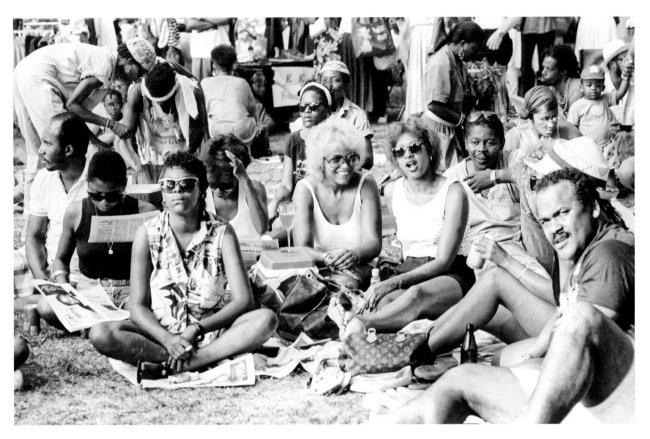

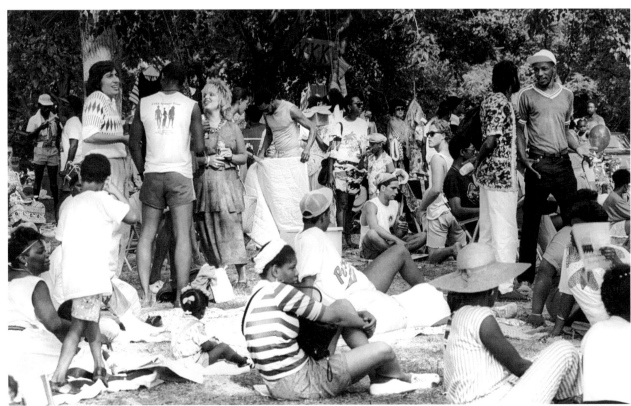

Sports & Special Events

Buoyed by Green Space and a Black Mayor

Sports and Special Events in Washington Park

Salim Muwakkil

Chicago's Black community was in an ebullient mood in the summer of 1987. Harold Washington had been elected as the city's first Black mayor just months earlier, and denizens of Washington Park, a verdant burst of greenery on the city's South Side, embraced Washington as the park's namesake. At least that's how it seemed when photographer Rose Blouin pointed her lens in their direction to chronicle summer fun.

While her subjects seemed particularly buoyant, she may just have captured the neighborhood's routine relationship with the joy of green space. Maybe the exuberance caught in Blouin's photographs is typical for basketball players on the park's courts. The baseball games that erupt in the park might always offer such entertaining victory dances, and practicing drill teams may regularly attract such rapt attention. But through Blouin's perceptive lens, these activities seem luminously unprecedented.

Assessments of urban neighborhoods invariably laud the presence of parks. Green spaces provide not just visual relief, but amenities otherwise unimaginable in the tumult of city life. The most recent research credits green spaces for tangible therapeutic benefits, like reduced blood pressure, cholesterol, and inflammation. The vigor of competitive games promises cardiovascular benefits as well. Washington Park seems designed with that in mind. A lagoon, glimpsed in one of Blouin's photographs being discovered by exploring youth, even offers the soothing tranquility of urban angling.

Chicago is famous for its Bud Billiken Parade, a back-to-school procession, featuring clusters of colorful floats, drill teams, baton twirlers, and color guards. The large-scale, bustling affair has traversed the South Side every August since 1929, culminating at Washington Park's 372 acres of open land. Blouin snares this unique arrangement with her snapshots of the summer of '87.

Blouin's panoramic portrayals also highlight Chicago's military identity with soldiers from the

Salim Muwakkil's decades of journalism have included serving as senior editor for *In These Times* magazine since 1984 and as a contributing columnist for both the *Chicago Sun-Times* and the *Chicago Tribune*. Muwakkil cofounded Pacifica News Network's daily *Democracy Now!* He has taught at Northwestern University, University of Illinois, the Art Institute of Chicago, and Columbia College Chicago. Hear him on *The Salim Muwakkil Show* on WVON-AM.

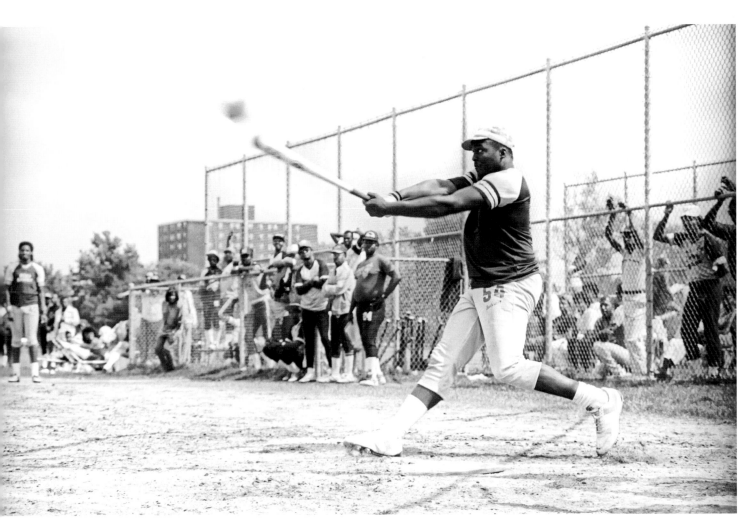

General Jones Armory. The opulent, ornately designed armory, named for a Black general who fought in both World Wars, is still operational, housing active National Guard units, an abrupt anchor to the park's recreational flow. But even the military men seem buoyed by the joyful vibe flowing through Blouin's photos.

The snare drums of marching bands are not the only percussive sounds echoing through Washington Park's trees during the summer. Bongos, congas, timbales, and cowbells add a tropical texture to the soundscape of a park that also serves as a focal point for a variety of cultural gatherings. Blouin's photographs include images of masquerade celebrants cavorting in the dark.

That summer also featured the expansion of the Black-on-Black Love campaign, sparked by entrepreneurs Edward and Bettian Gardner to counter the "black-on-black crime" narrative that seemingly had the national media on lock. The optimism and self-determination of the era is depicted in evocative tees heralding "No Crime Day" and "Black by Popular Demand" among the African bubas and dashikis.

With this celluloid compilation of neighborhood attitude, Sister Rose captured the spirit of Washington Park. She caught a rare historical moment of cultural shift, triggered by Mayor Washington's unprecedented ascendancy. The trajectory for a brighter Black Chicago seems crystal clear through Blouin's lens.

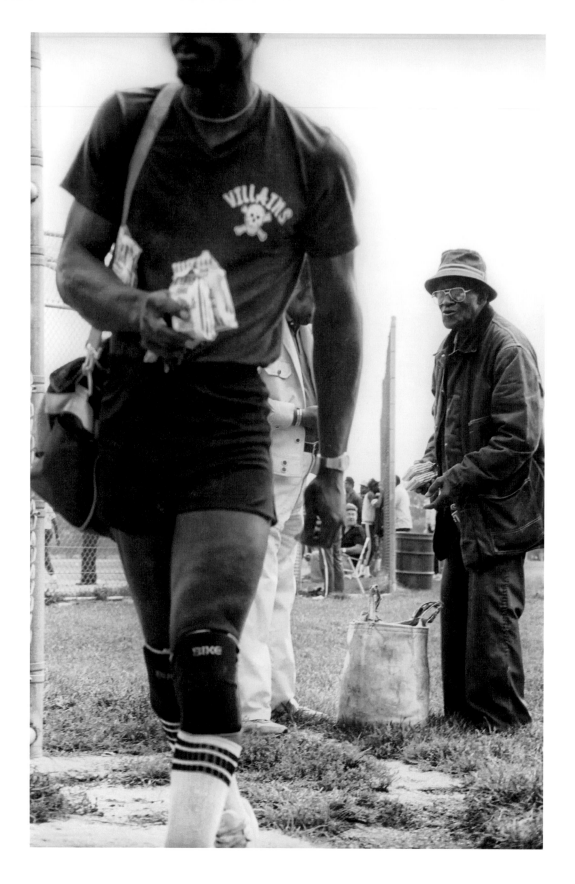

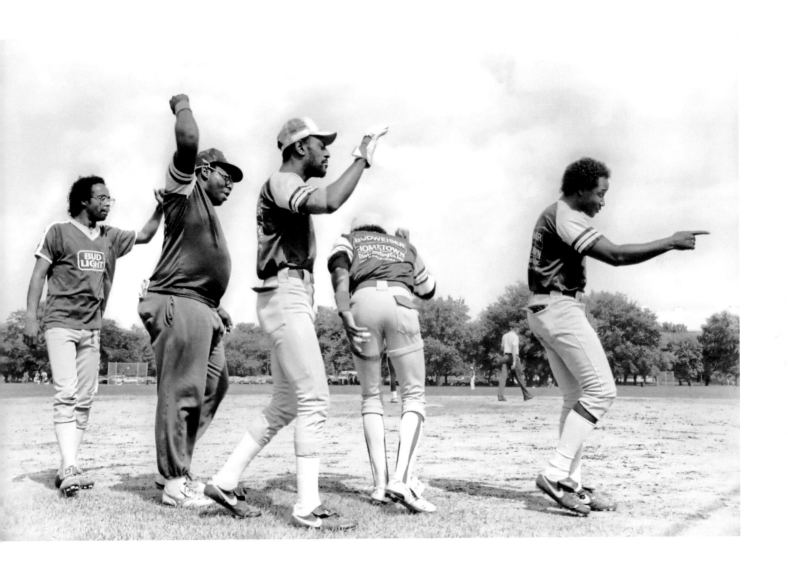

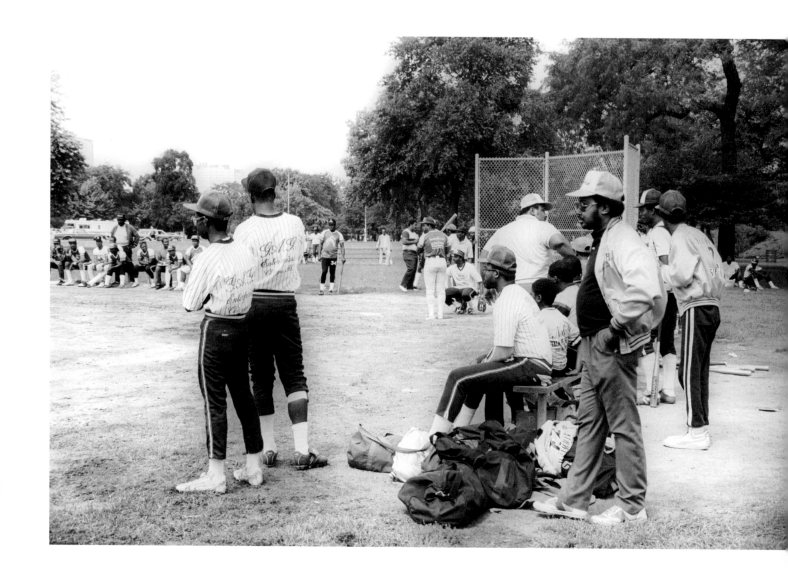

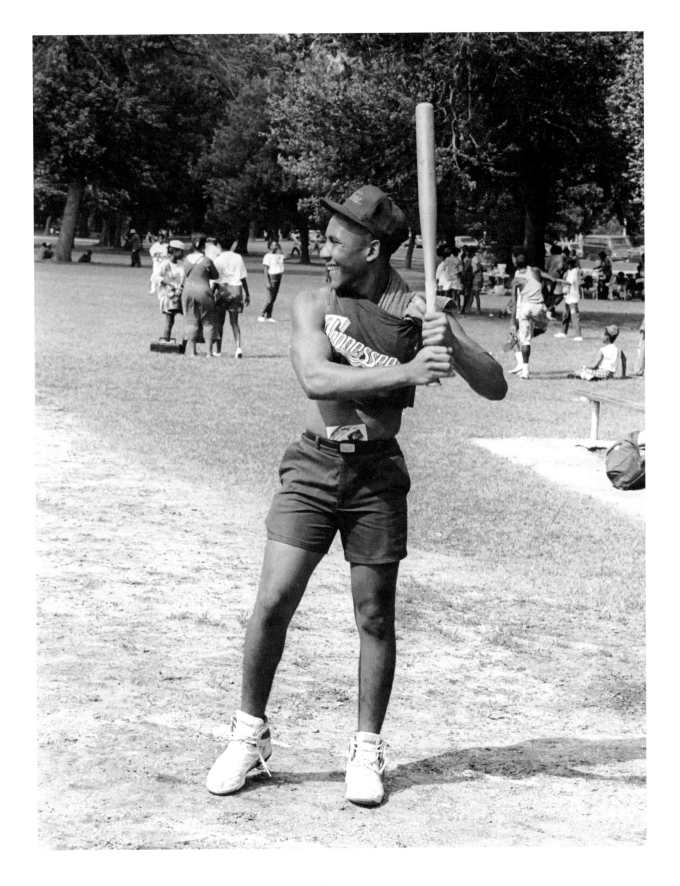

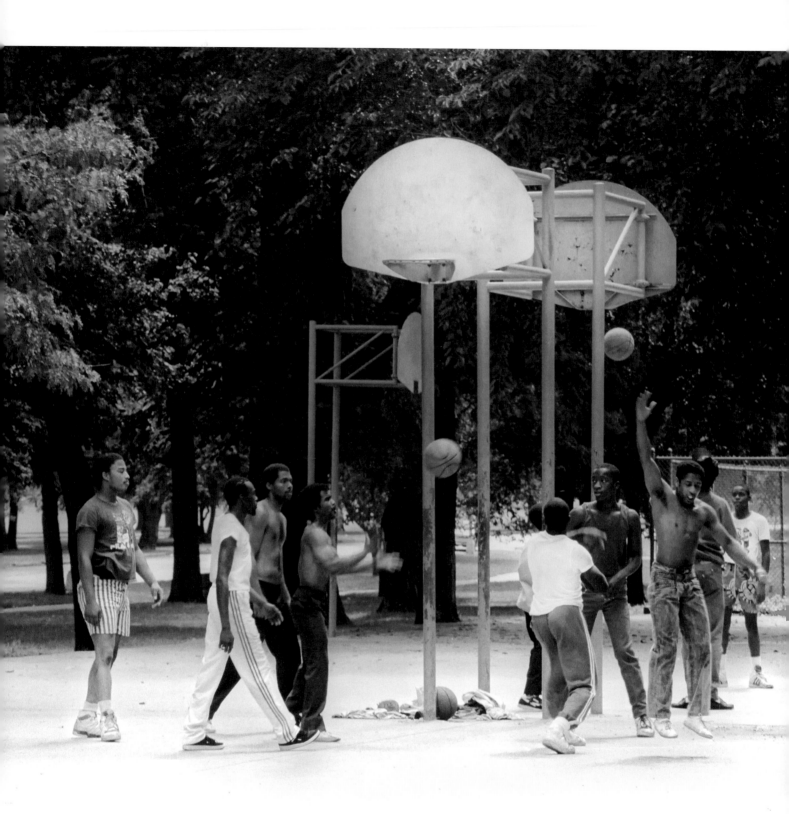

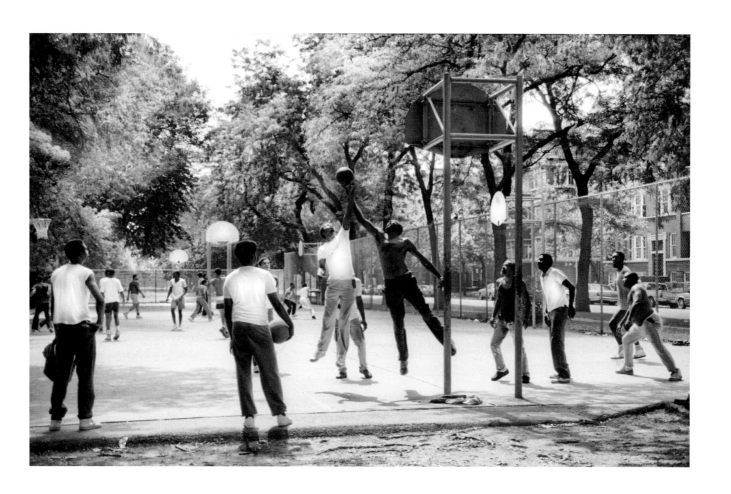

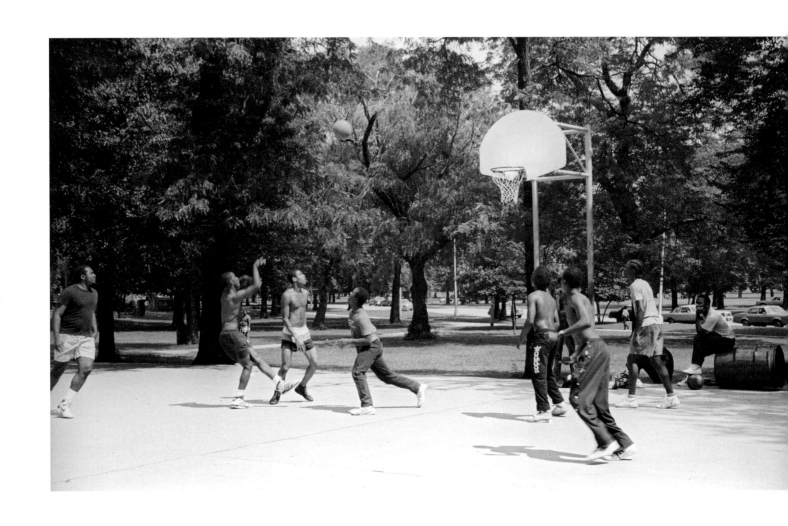

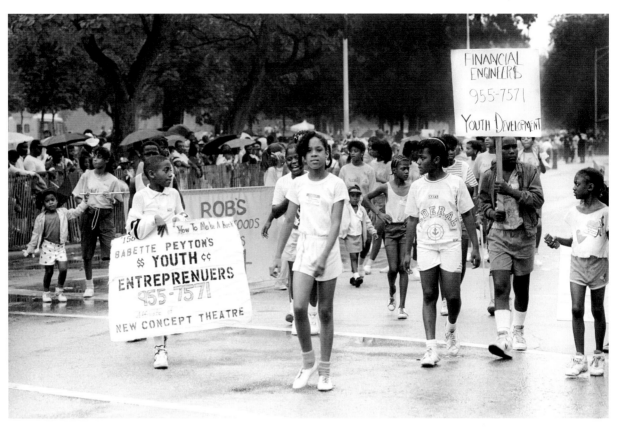

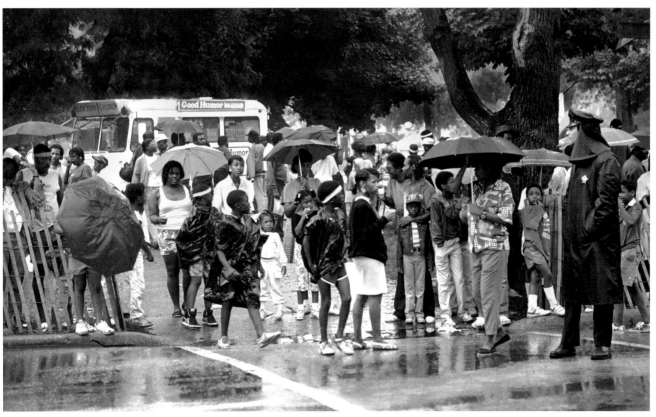

47

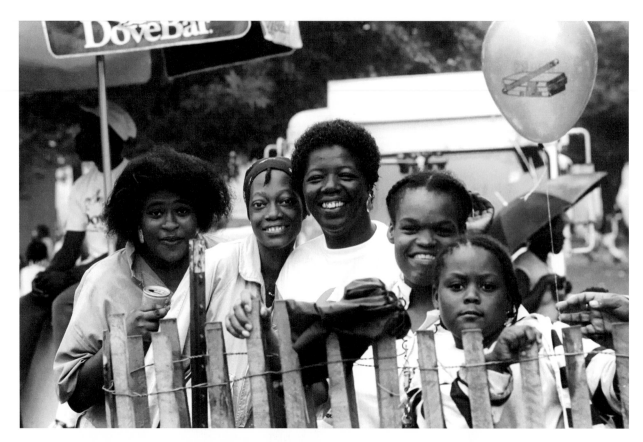

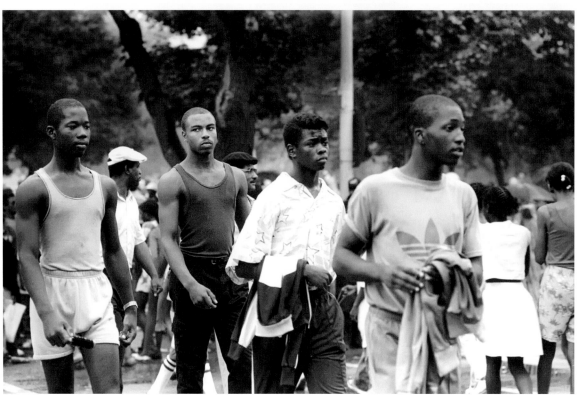

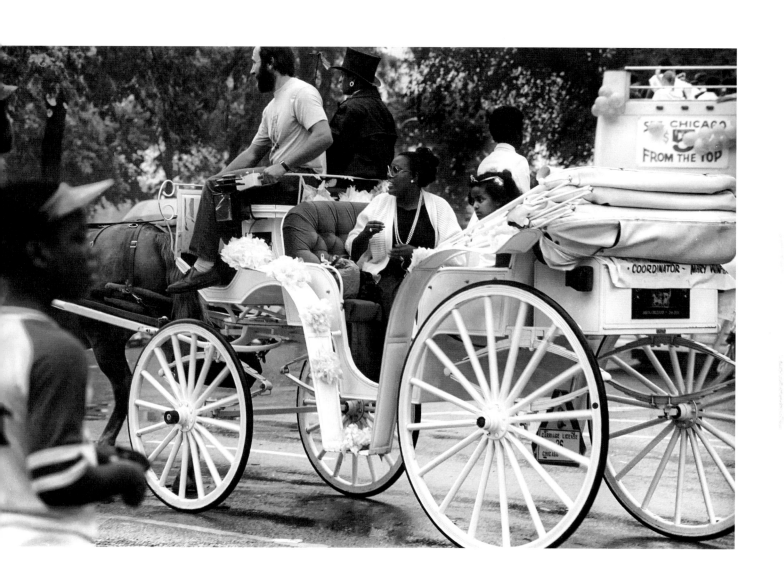

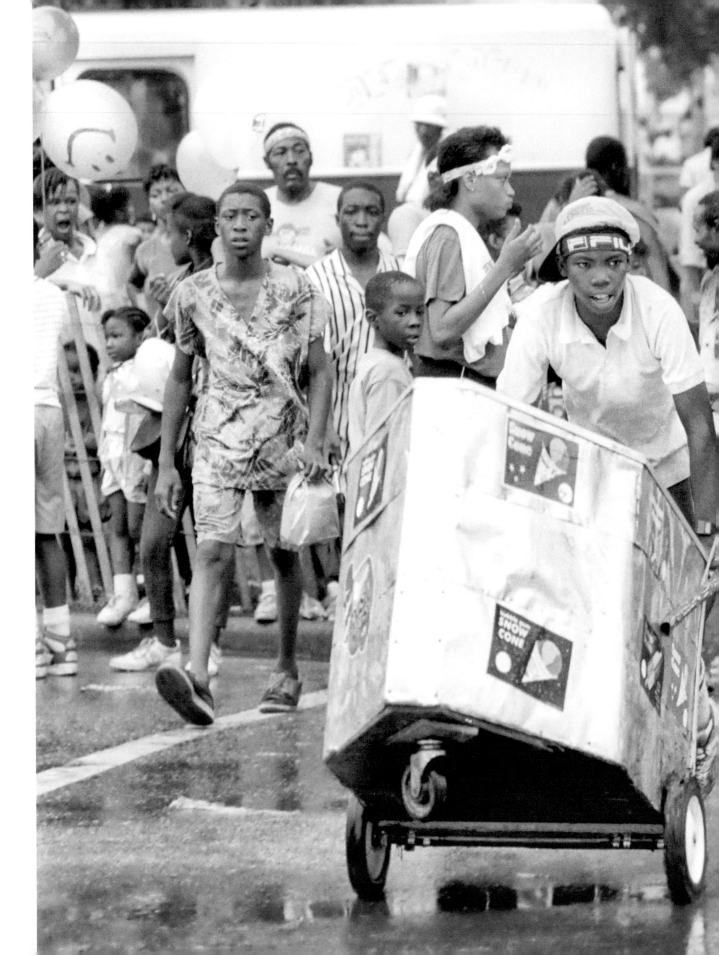

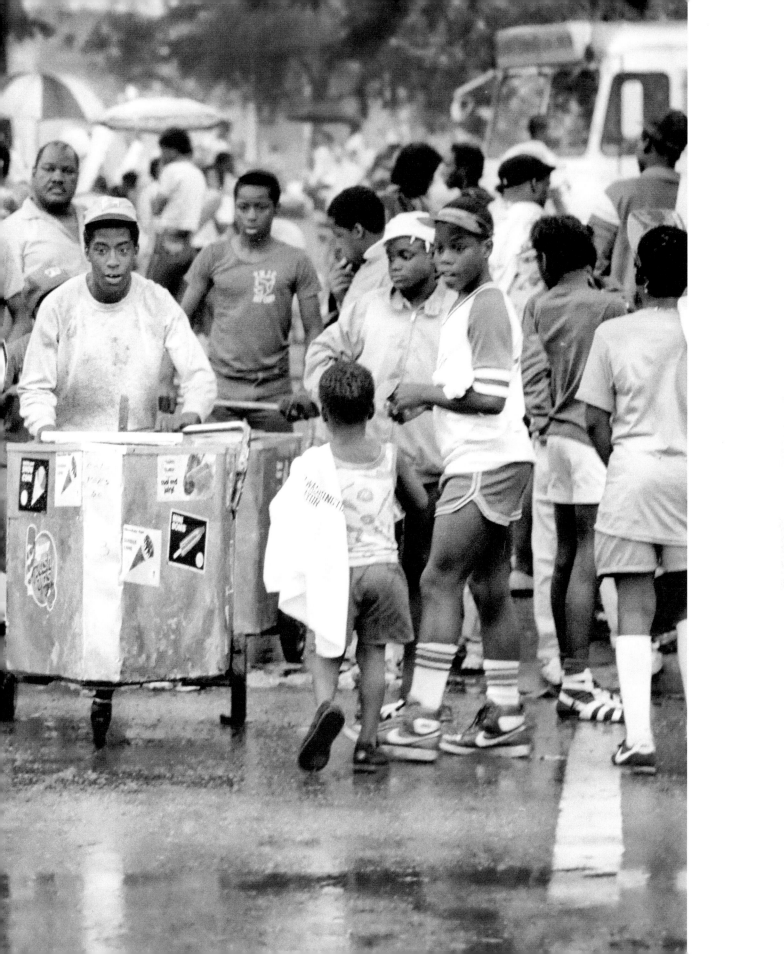

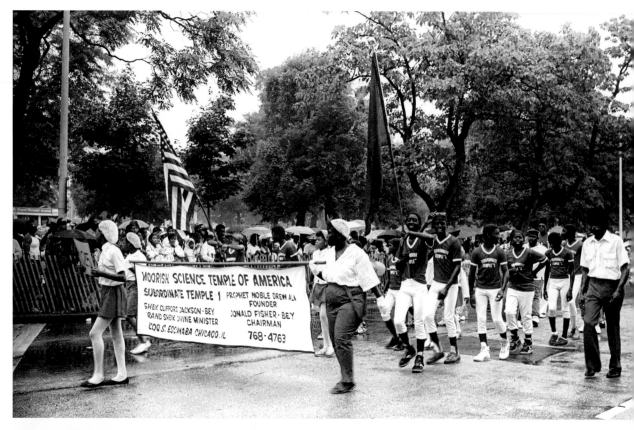

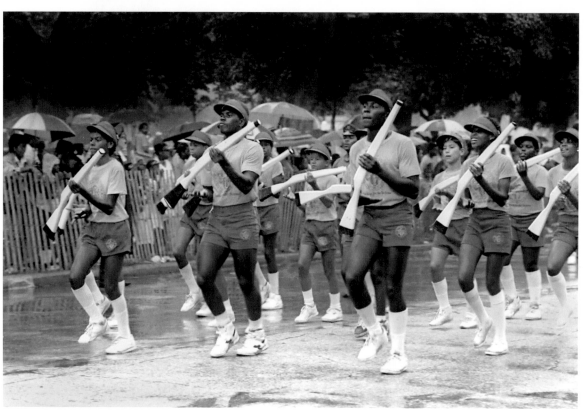

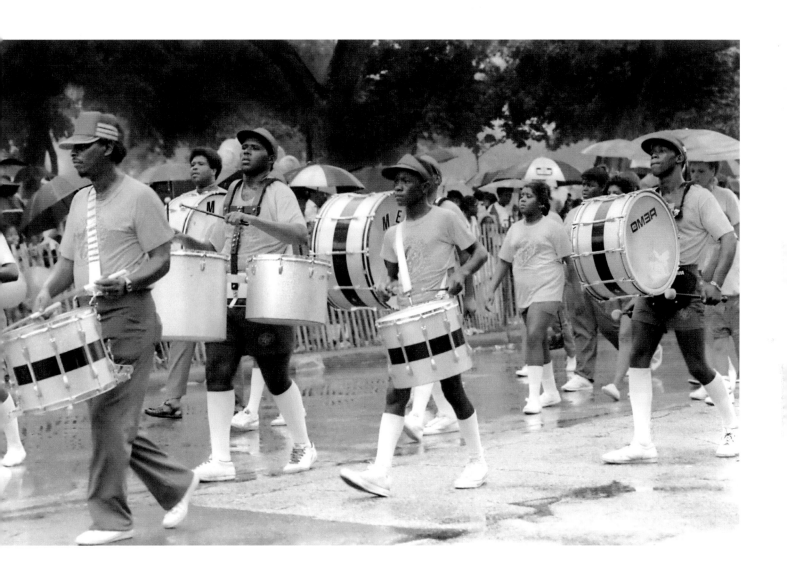

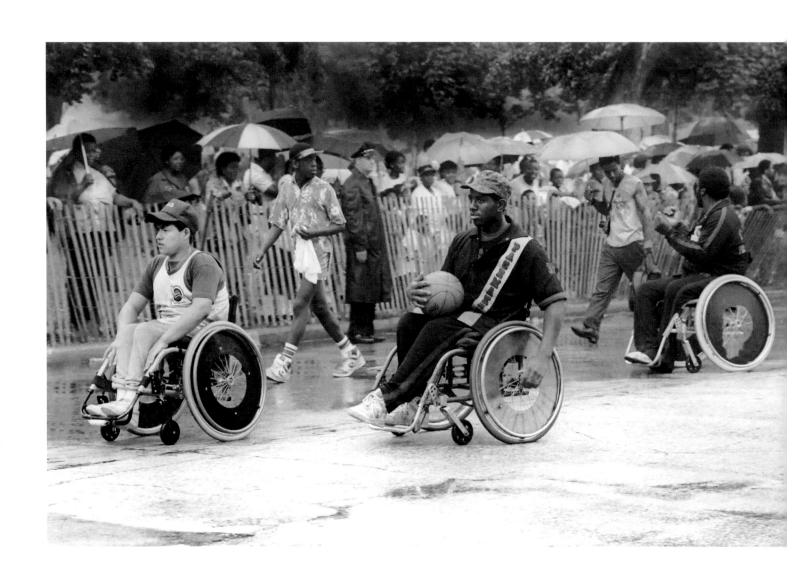

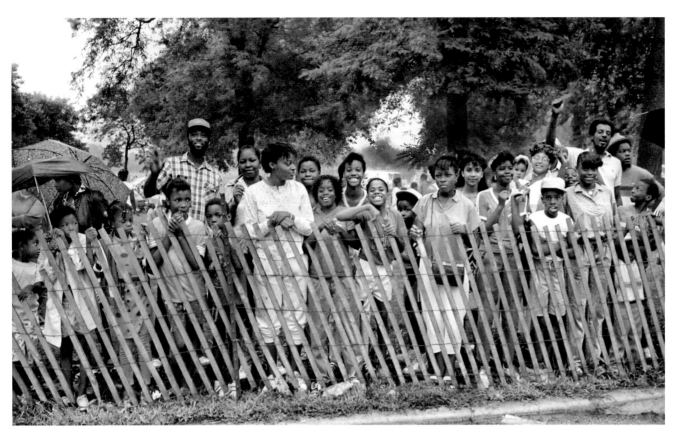

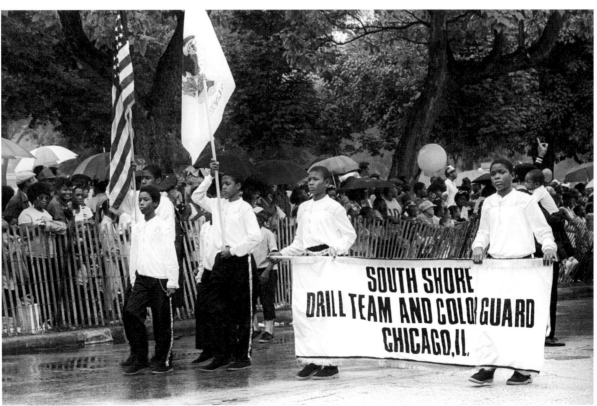

SOUTH SHORE
DRILL TEAM AND COLOR GUARD
CHICAGO, IL.

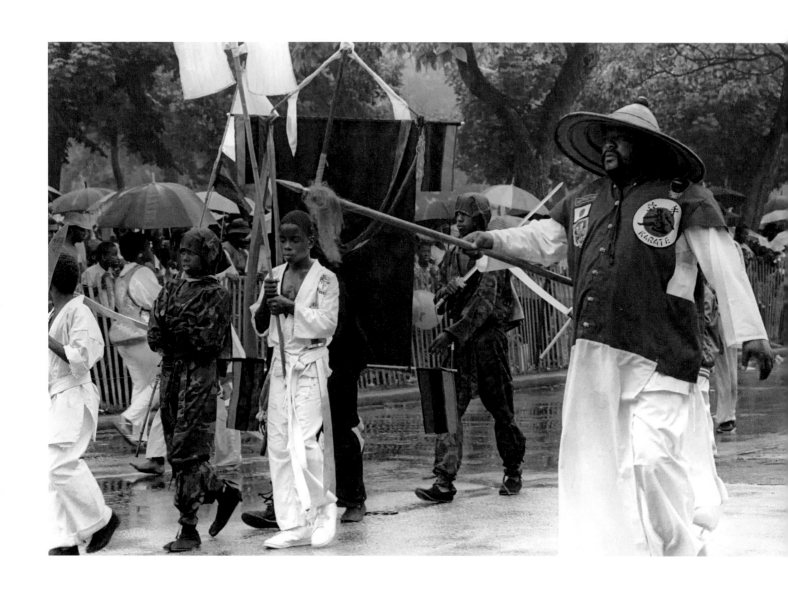

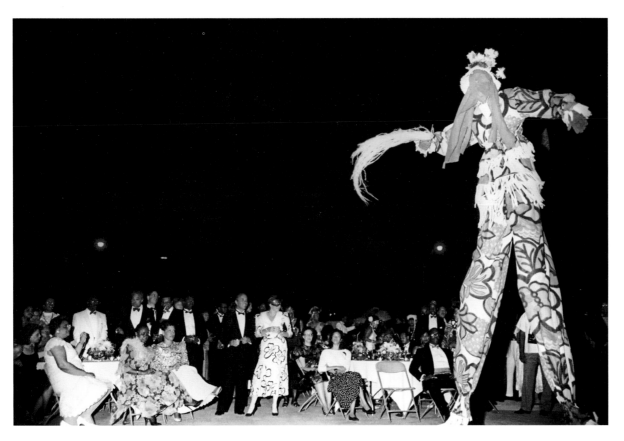

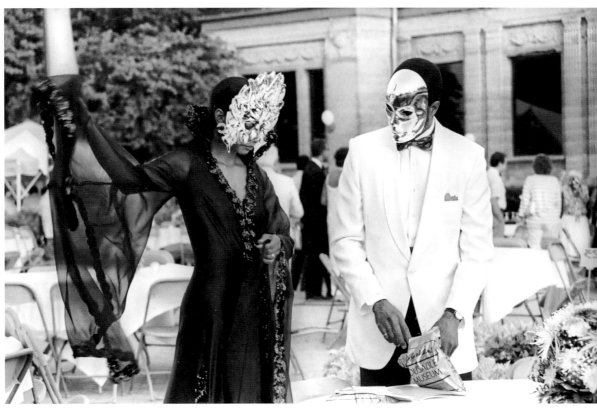

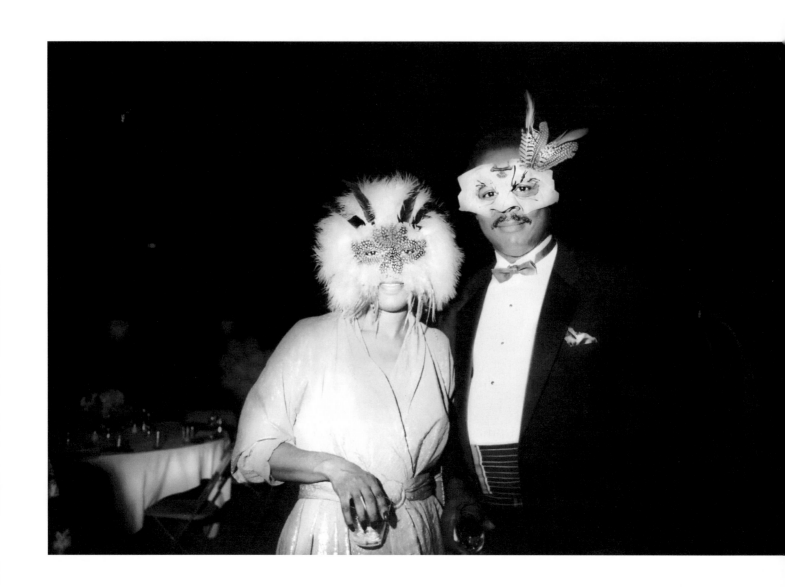

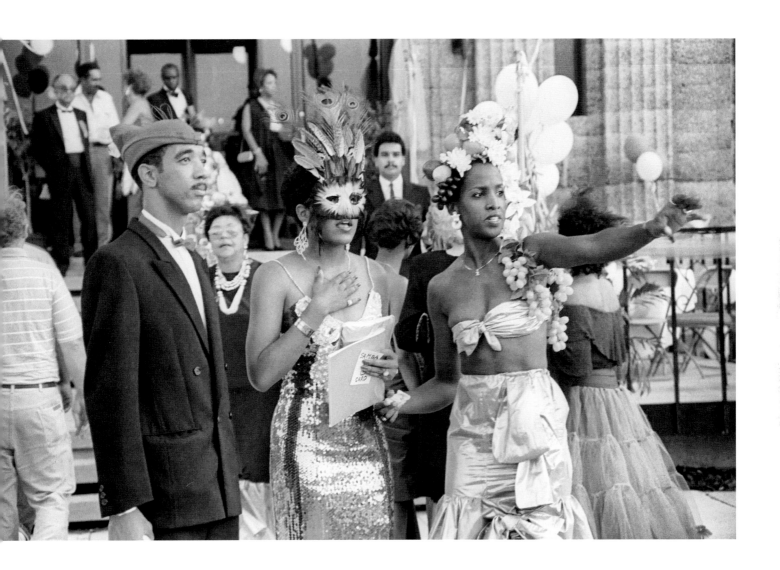

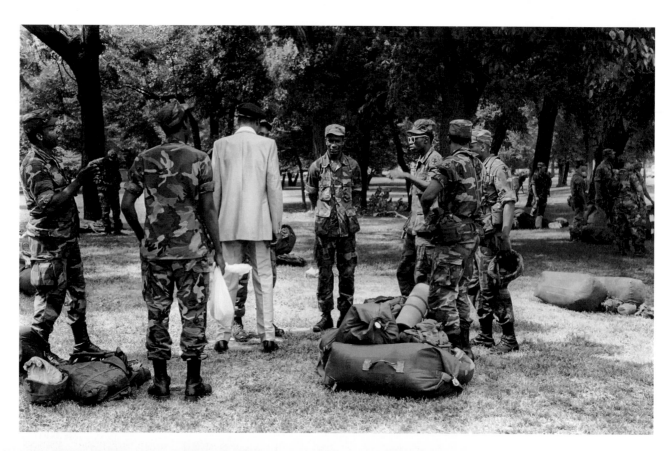

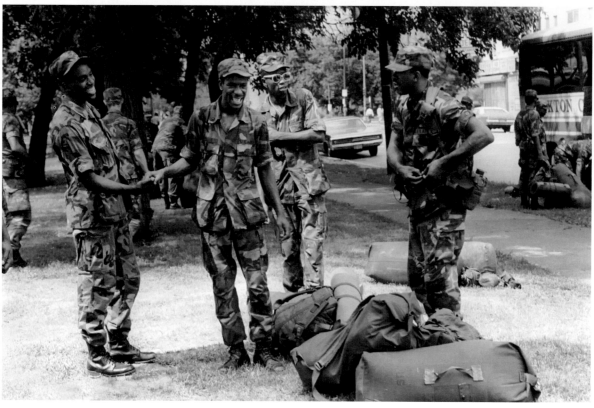

60

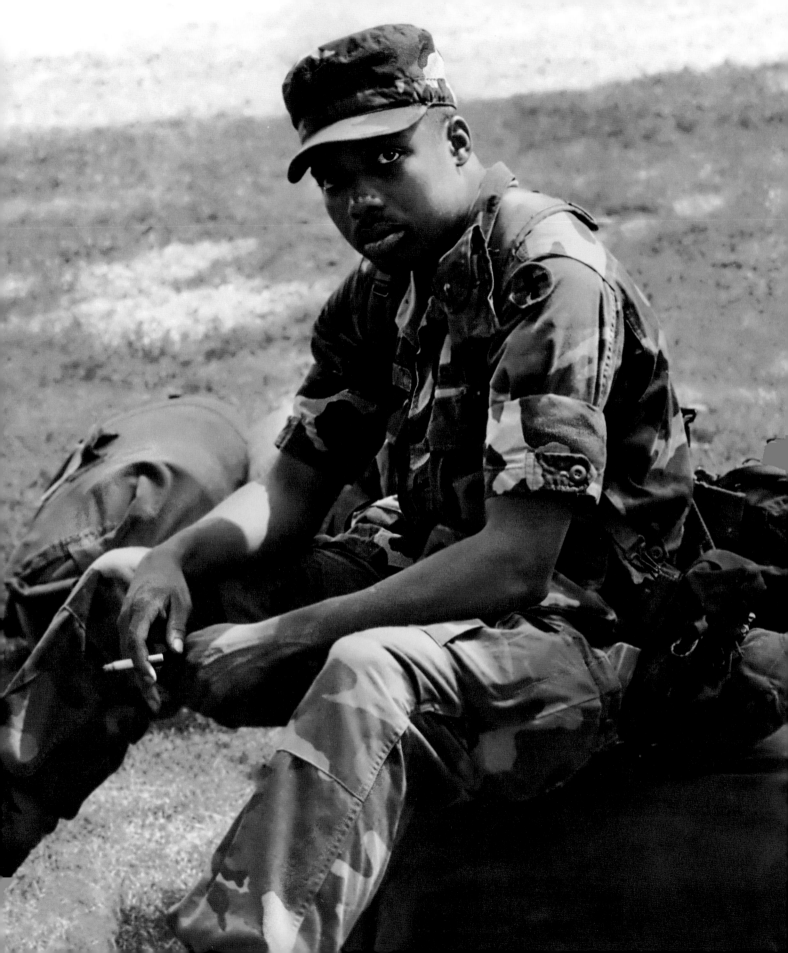

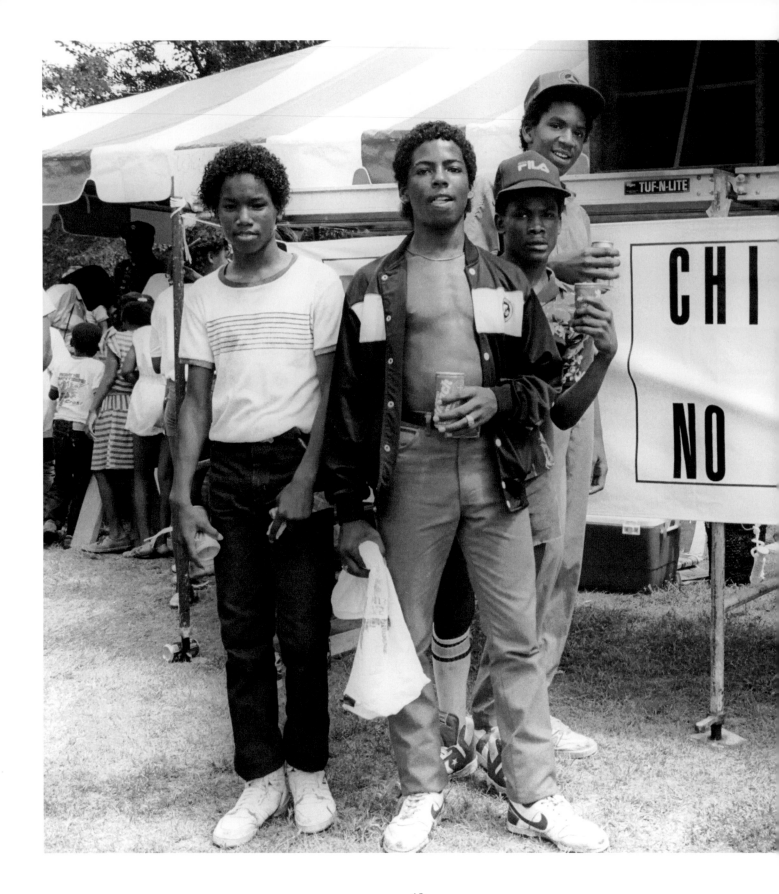

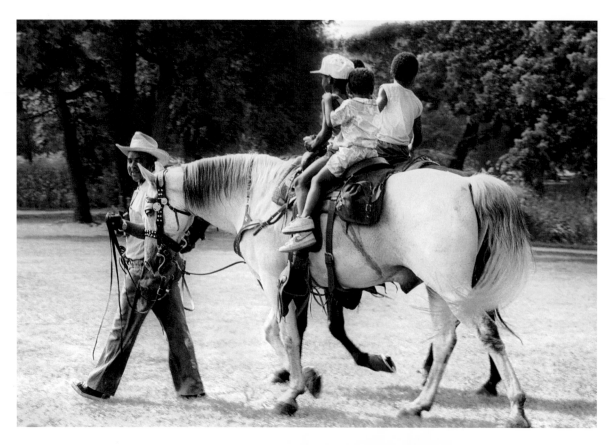

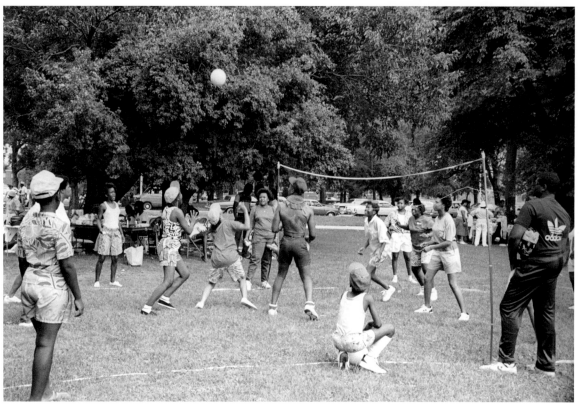

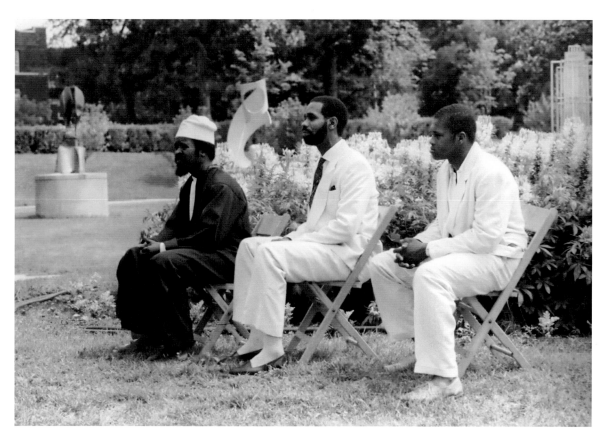

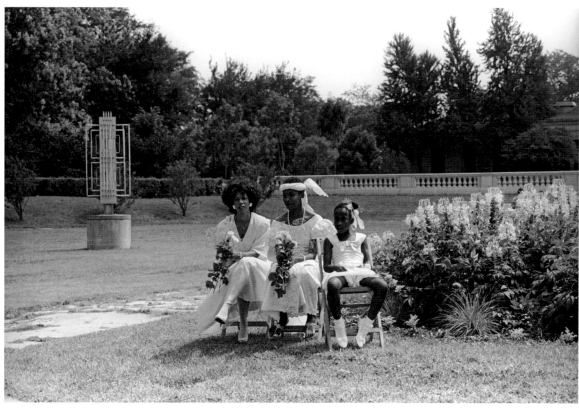

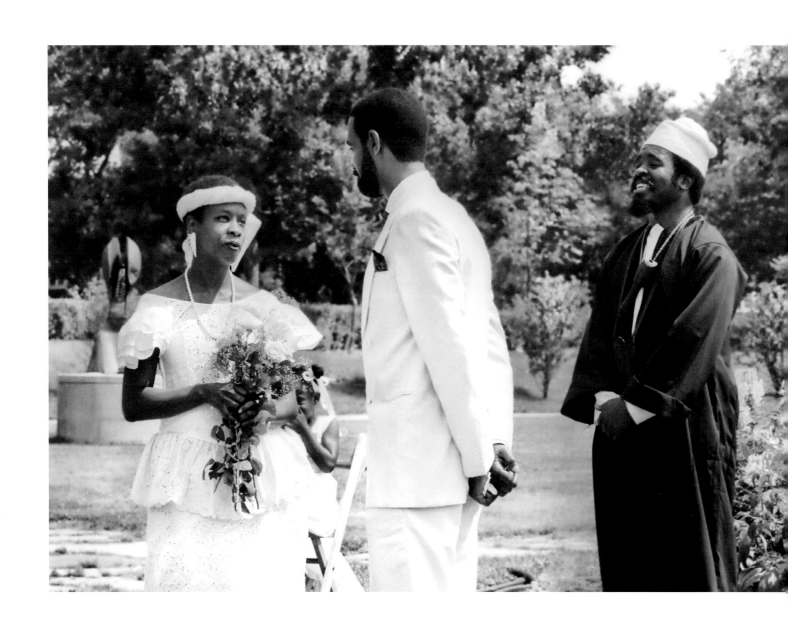

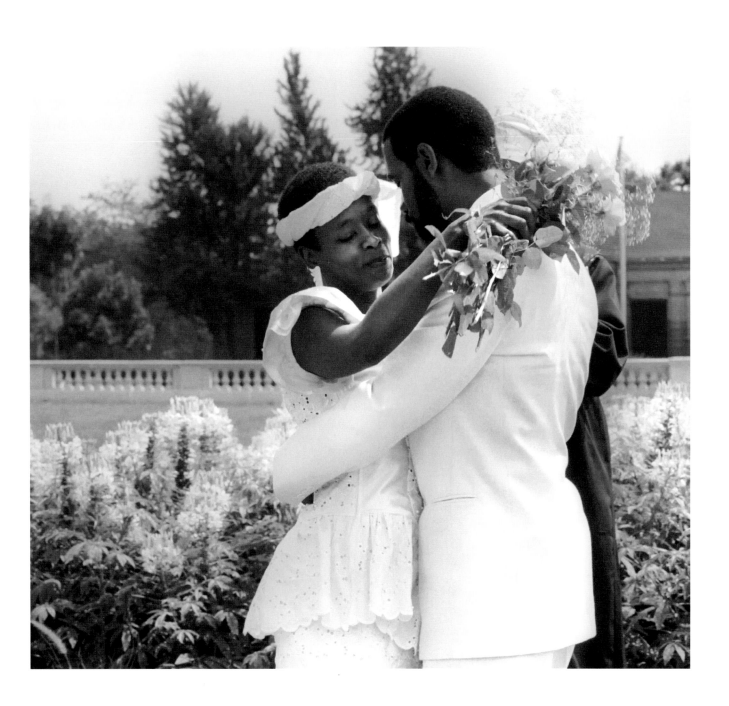

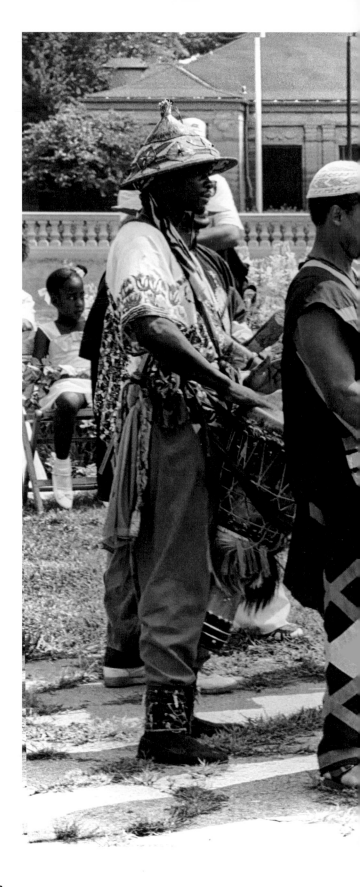

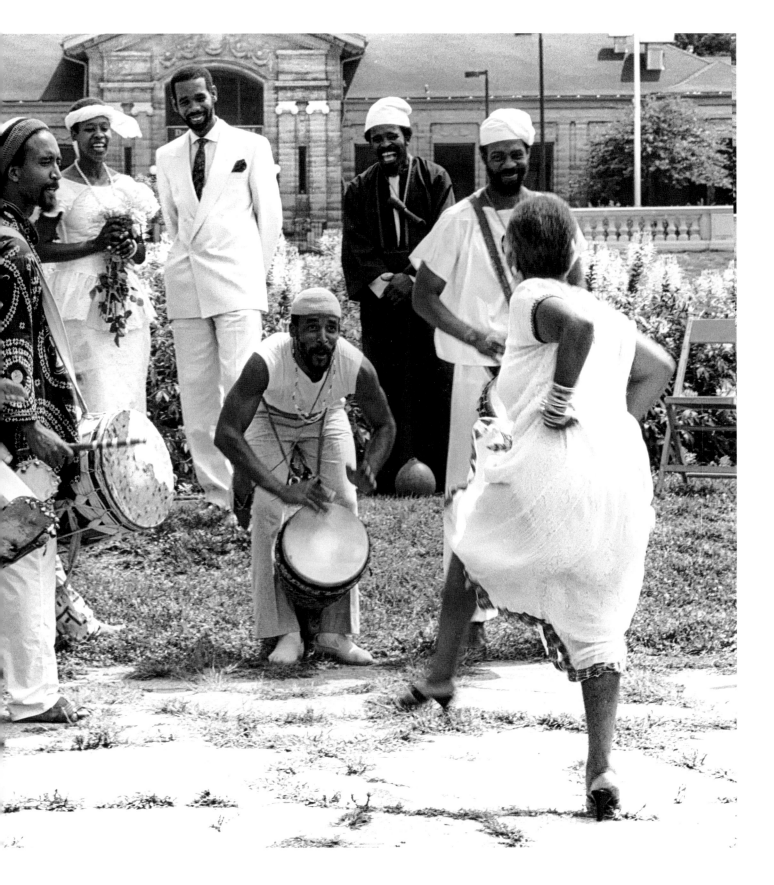

Art, Music, Culture, and Community

Happenings

Art, Music, Culture, and Community in the Photography of Rose Blouin

Romi Crawford

1987 is a unique year, but the happenings in Washington Park that took place then are not so unlike those that take place now in 2024, or what they were like in 1970. Ten years from now will likely bring comparable occurrences. The continuum of circumstances is fascinating and eerie. The black and white of Blouin's images make the resonating similarities between the happenings then and now even more pronounced.

When photographed, these happenings become archival within moments of the images being shot. They connect to and reference ongoing social incidents that precede and undergird the events. In effect, the images are more loaded than they seem upon first glance. Yes, they represent scenes of Black community at the park, but they also index complex social dynamics that came before and endure beyond the time of the photograph. What the images don't reveal is as important as their immediate content.

What the photographs do bear out immediately is a record of music, dance, and performance, but they also relay an idea of art that goes beyond these obvious forms. The photographs really are of *happenings*, art that is too formally expansive and uncontained to fit on a wall, staged in a venue or to take place during a two-hour interval. They offer a projection of art that is all day long, outdoors, embedded in entrepreneurial efforts and on display in dress and hair styles. The photographs help to locate this expanded notion of art that is happening, flowing from music to dance to processions to fashion, and so on. The art and creative energies are part of the very atmosphere that Blouin photographs.

Romi Crawford, PhD, has a research practice that explores areas of race and ethnicity as they relate to American visual culture (including art, film, and photography). Her work often centers on, and expands the bounds of, Black Arts Movement ideas and aesthetics and positions pedagogical impulses in relation to art making. Recent projects include "Citing Black Geographies" (Richard Gray Gallery, 2022) and "So Be It! Ase!: Photographic Echoes of Festac '77" (Richard Gray, 2023). Crawford is founder of the Black Arts Movement School Modality and the New Art School Modality, and is professor in the Visual and Critical Studies department at the School of the Art Institute of Chicago.

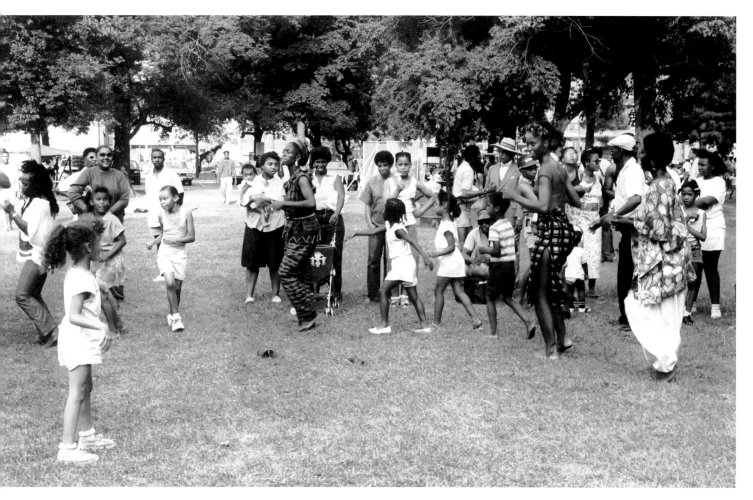

The images also facilitate our appreciation of the park as an architecture, one that supports creative expression and helps contain the continuous flow and adjacency of these varied art forms. Insofar as the park reads like a living room, like a front porch, like a dance floor, like a social club, like a gym, like a storefront, like a concert hall, it also reads like a museum or gallery space.

We glean from the images this use of the park as an arts space. This discloses the need for arts venues that can hold the multi-formal, social complexity of creative agencies that evolve from Black cultural expression. In lieu of something more formal, enclosed with doors and windows and at a price point too precious, the Washington Park space suffices for this free-flowing range of expressions. The images prove that the park fulfills so much more than the need for fresh air and greenery; it's a precinct where art forms might correlate and combine toward the production of something evanescent and impossibly intertwined with the people gathered there.

Blouin's photographs address the specificity of this creative district where clothes, hair styles, and Africanisms of all sort spell out cultural urgencies. A T-shirt reads, "Black by Popular Demand." There are a range of barriers that often thwart these people's movement to other, fancier art spaces beyond Washington Park. Blouin's images expose a responsive counterpoint to all of that: art *happening* outside white cubes and museums, couched within the life of the urban green.

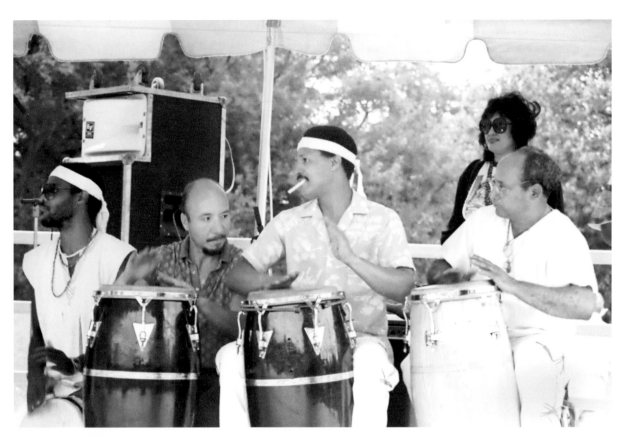

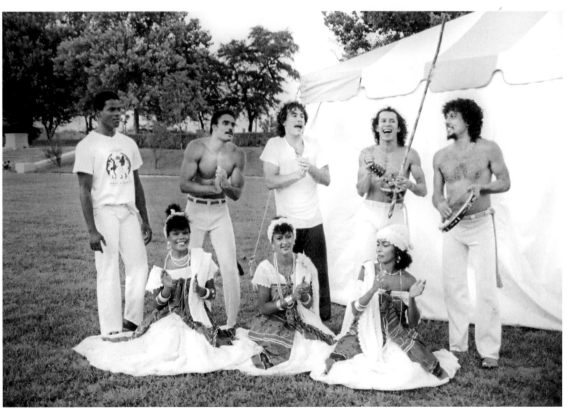

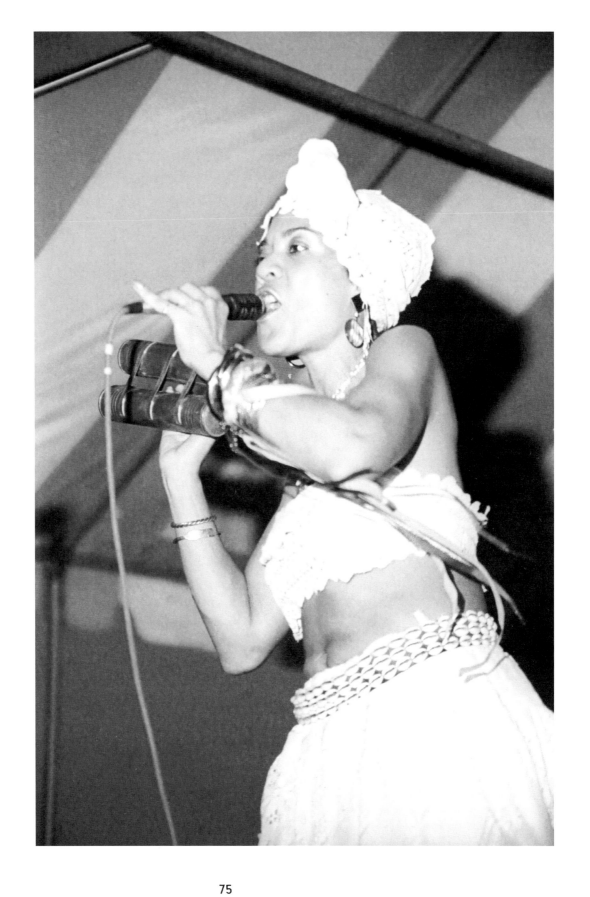

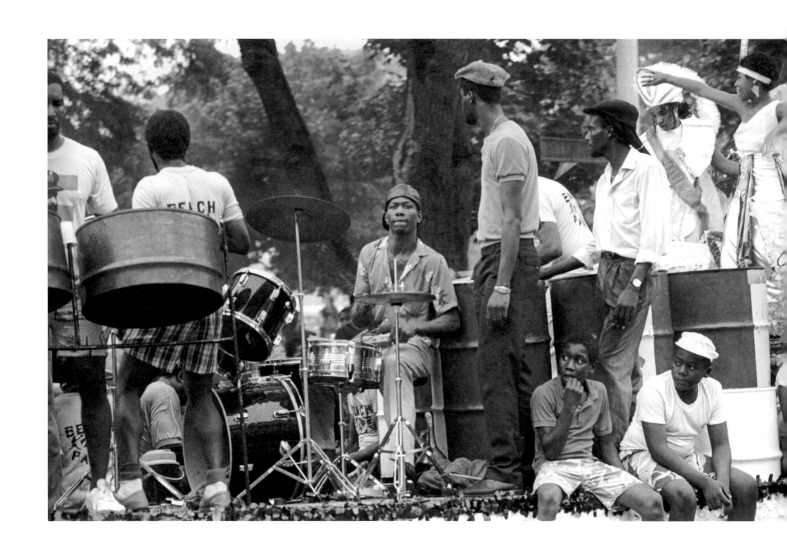

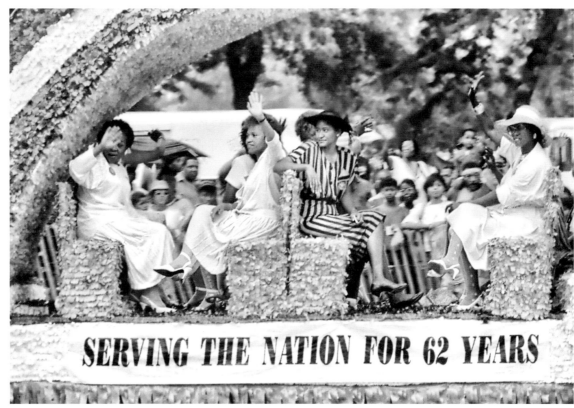

SERVING THE NATION FOR 62 YEARS

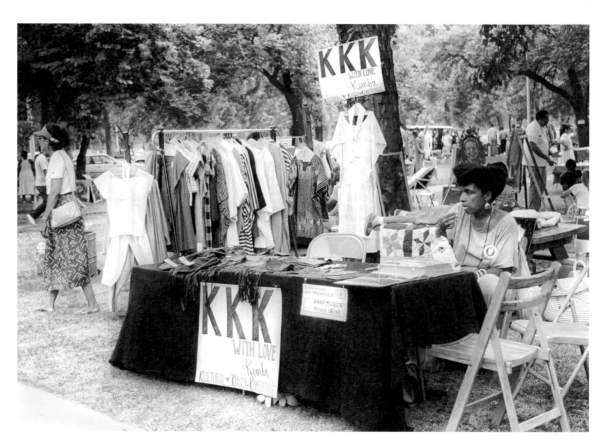

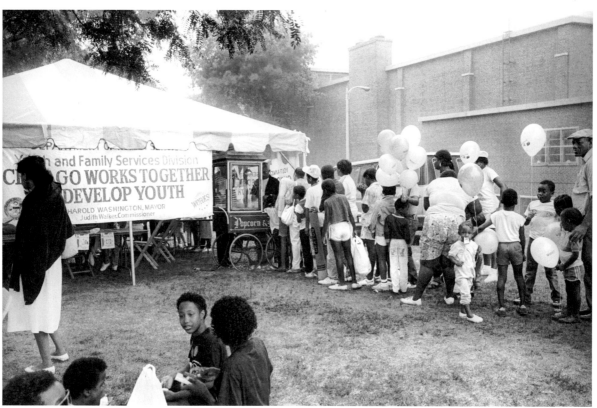

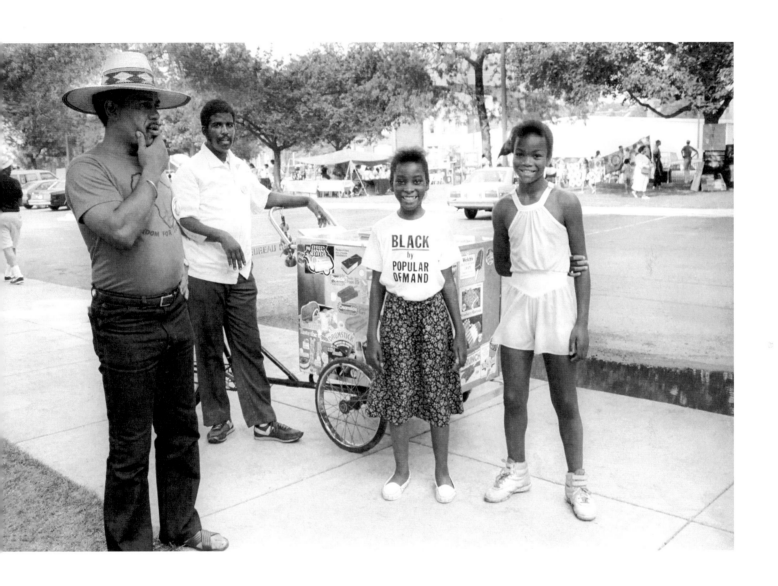

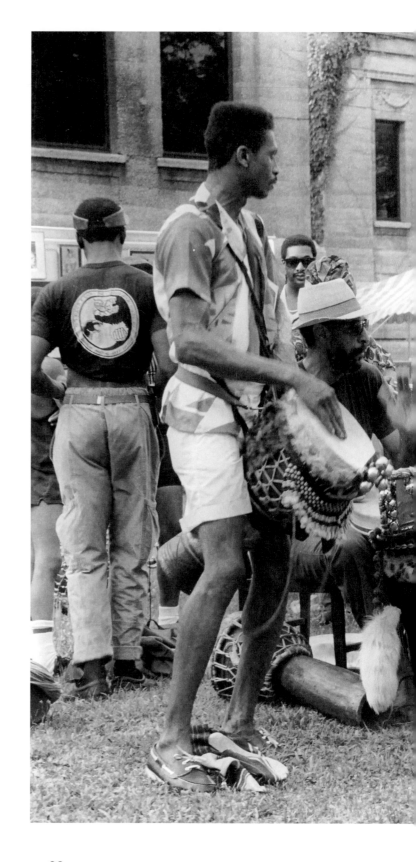

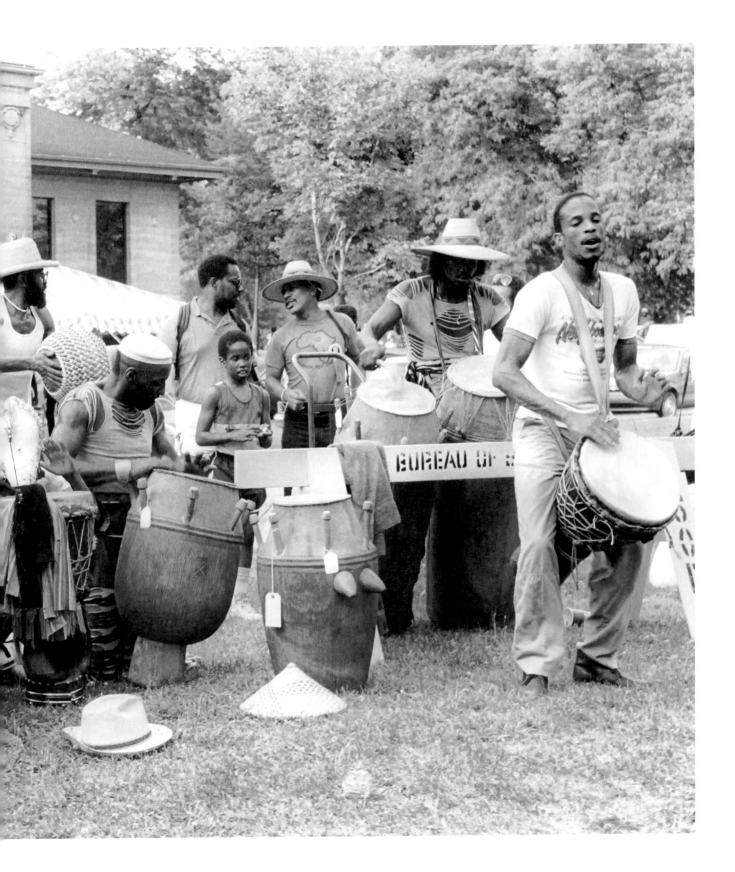

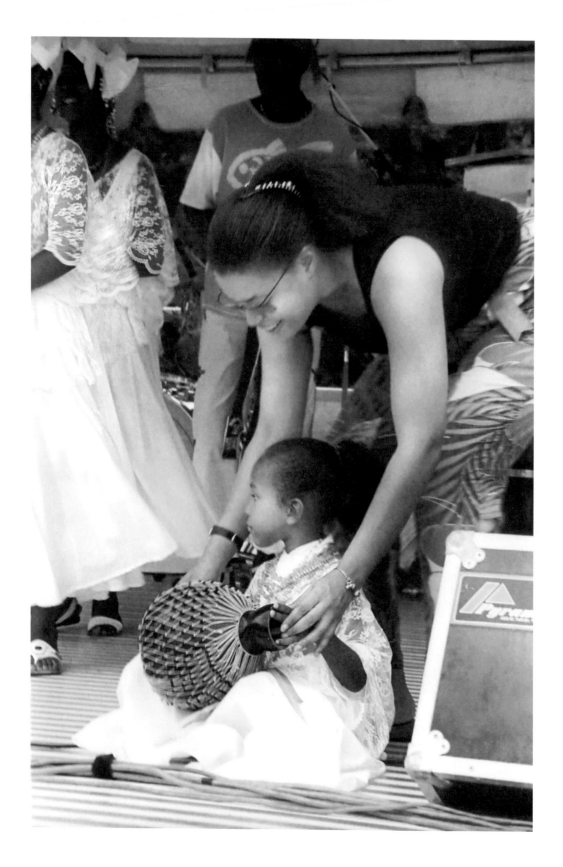

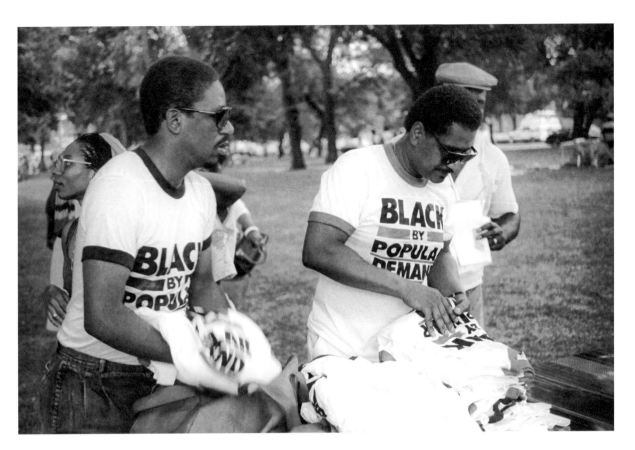

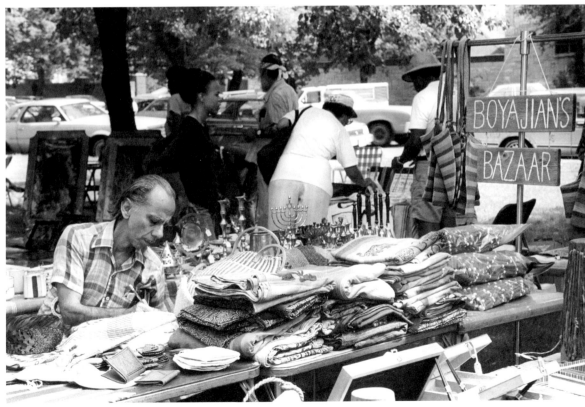

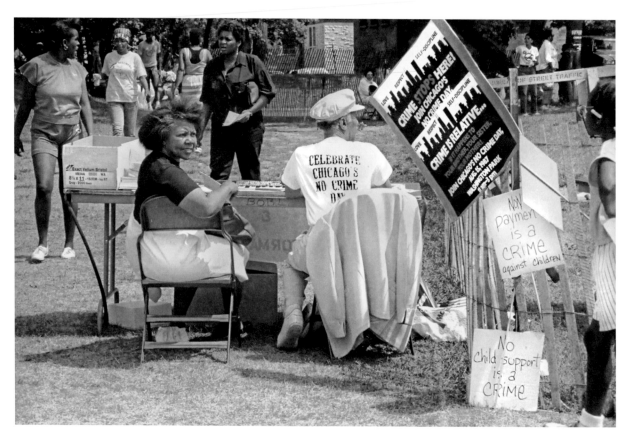

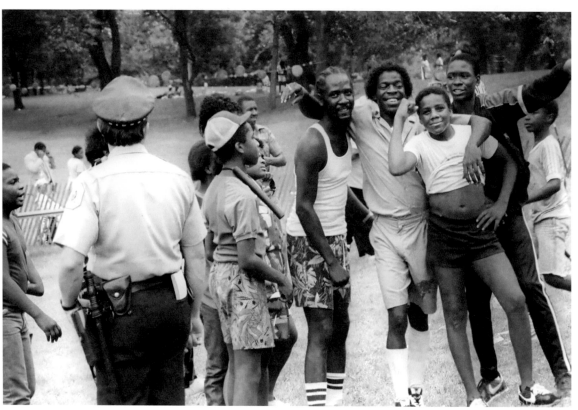

84

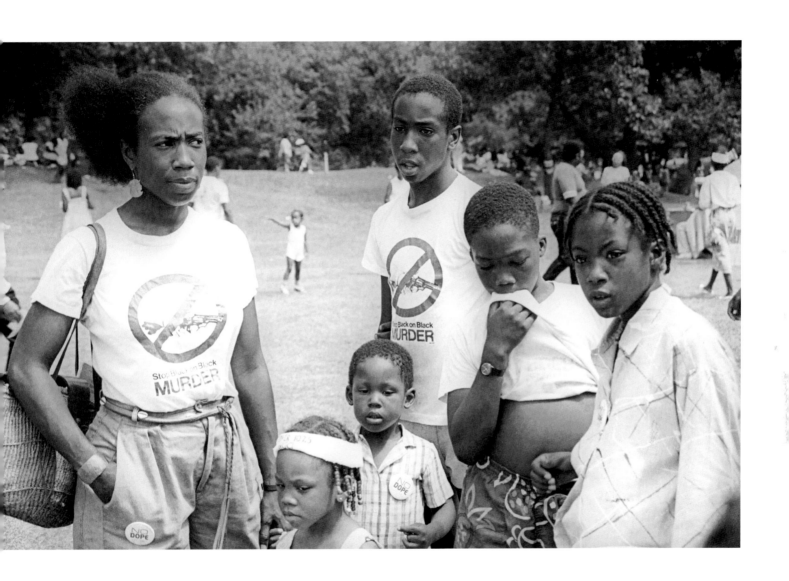

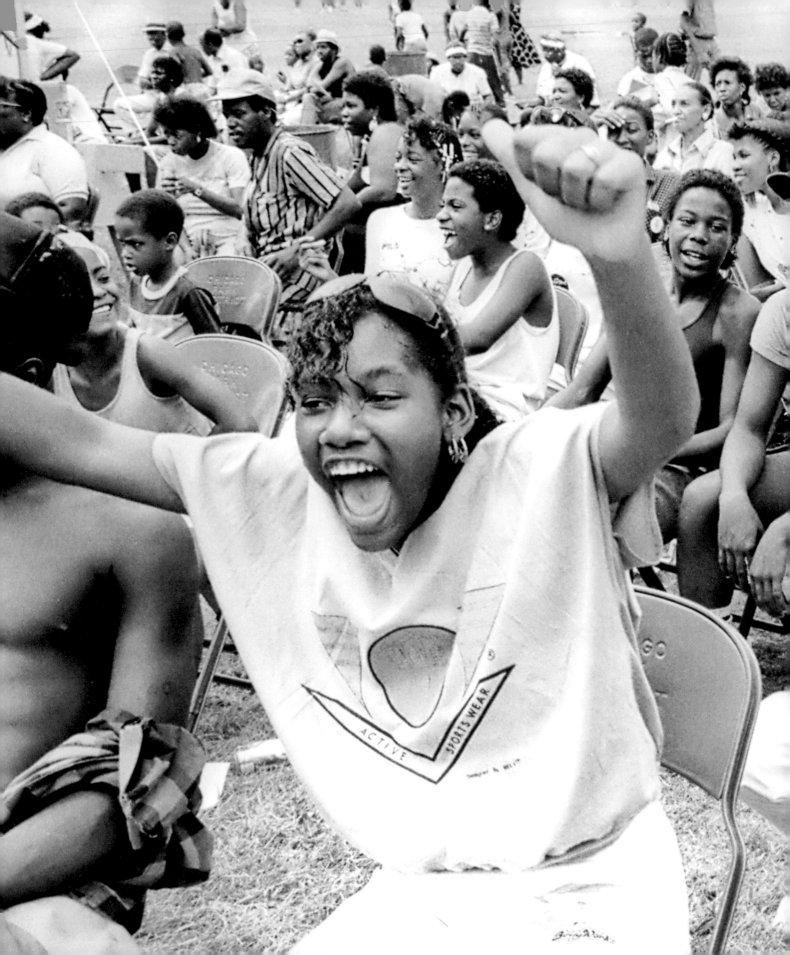

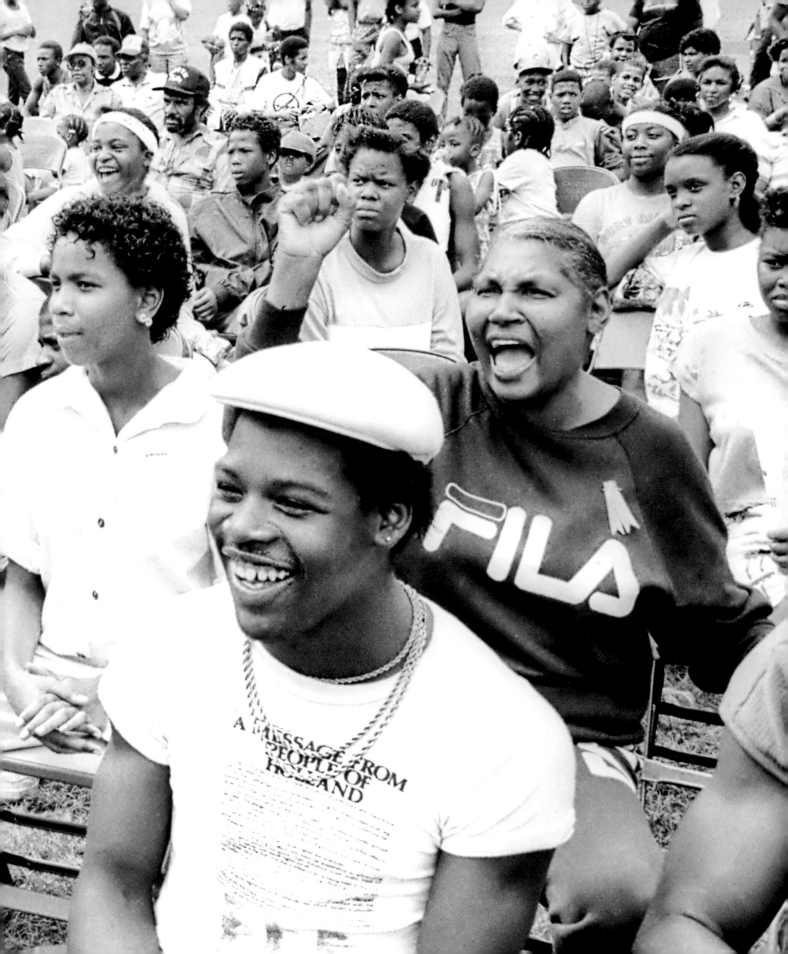

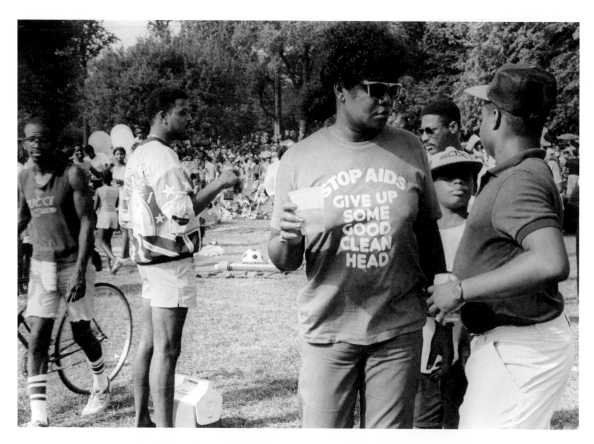

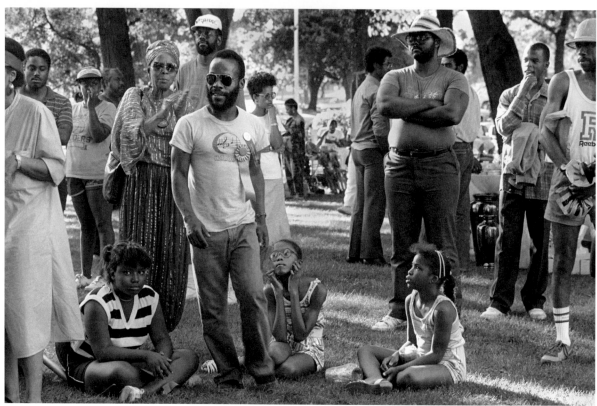

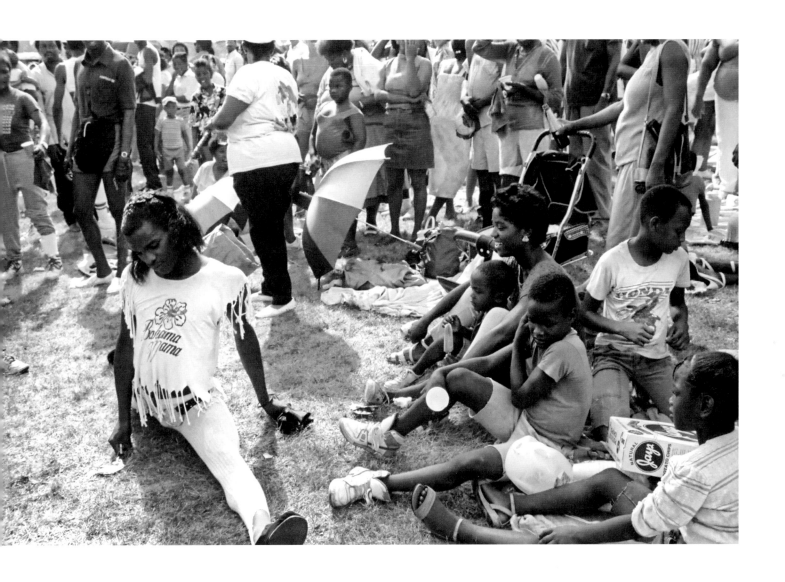

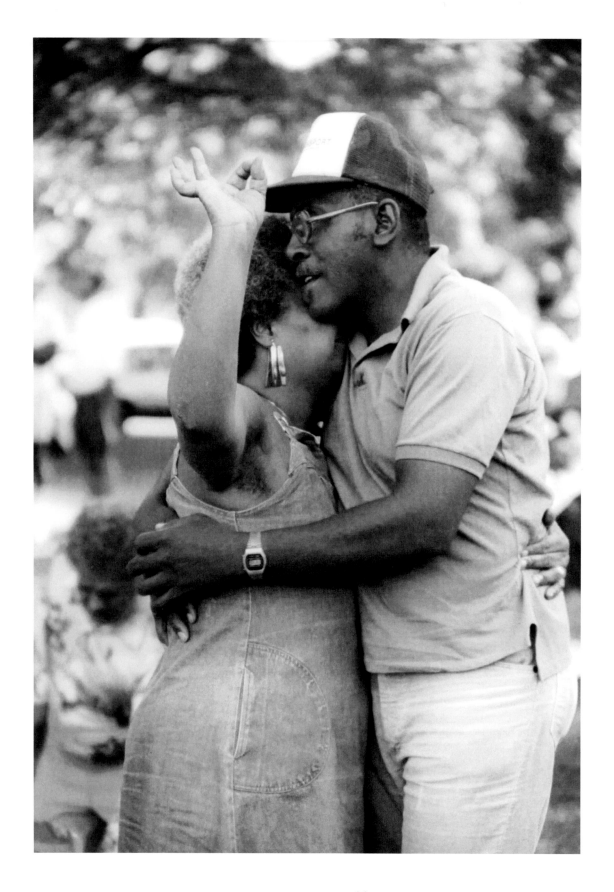

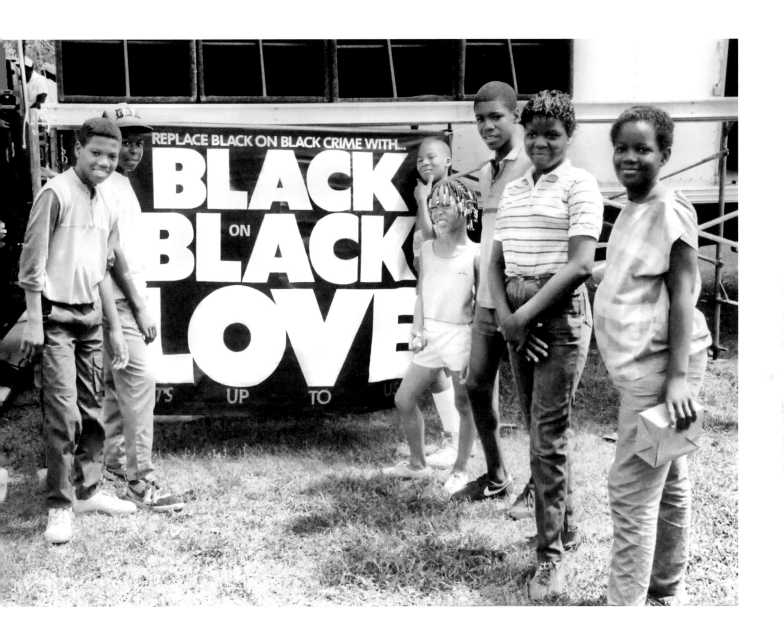

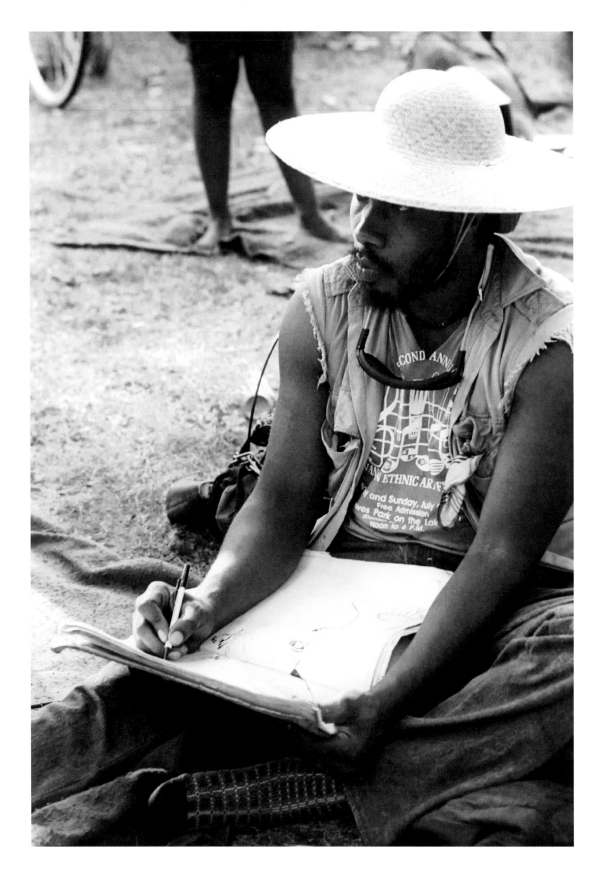

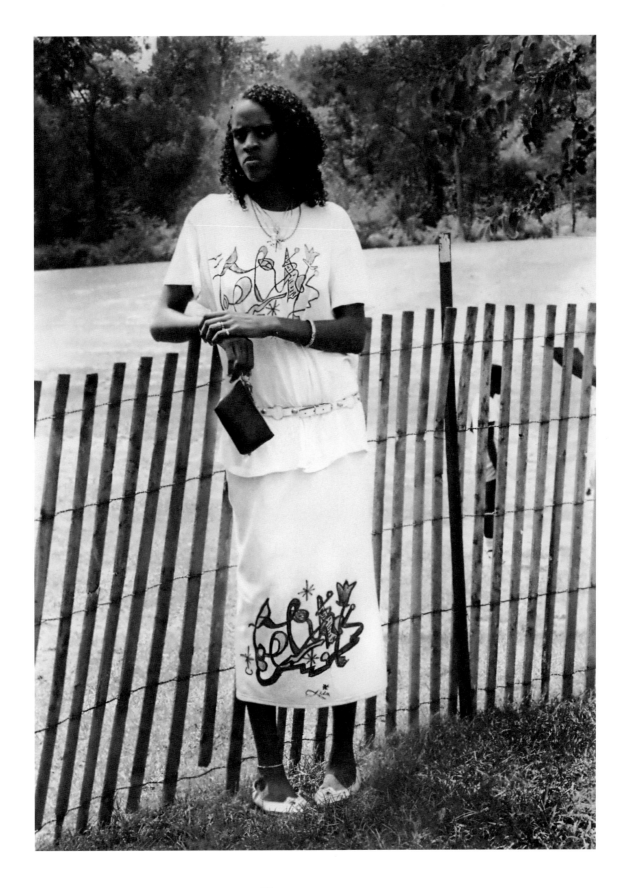

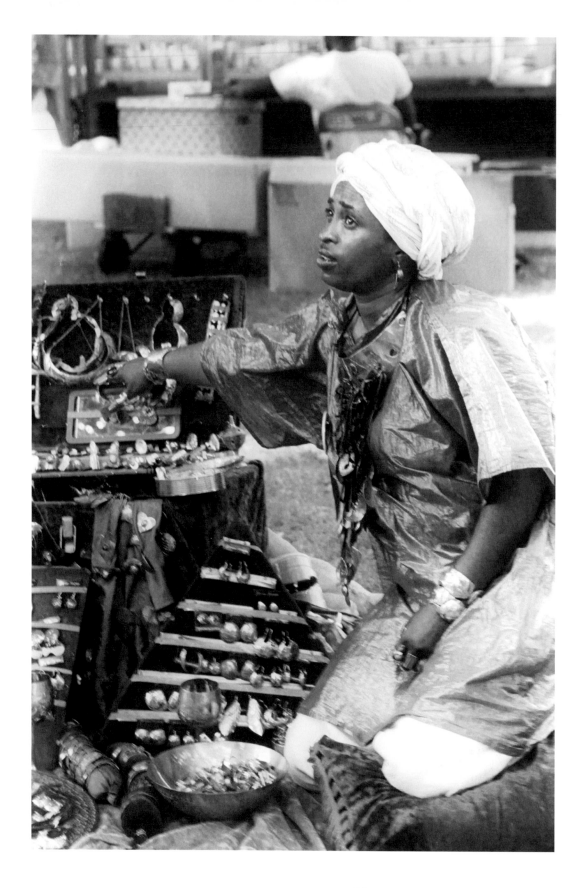

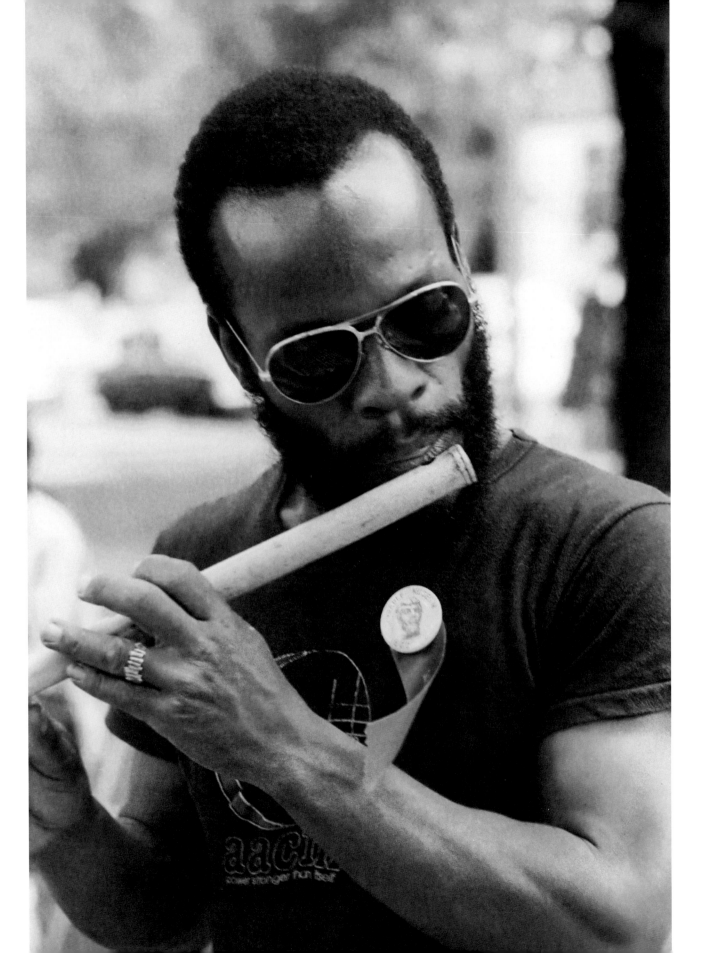

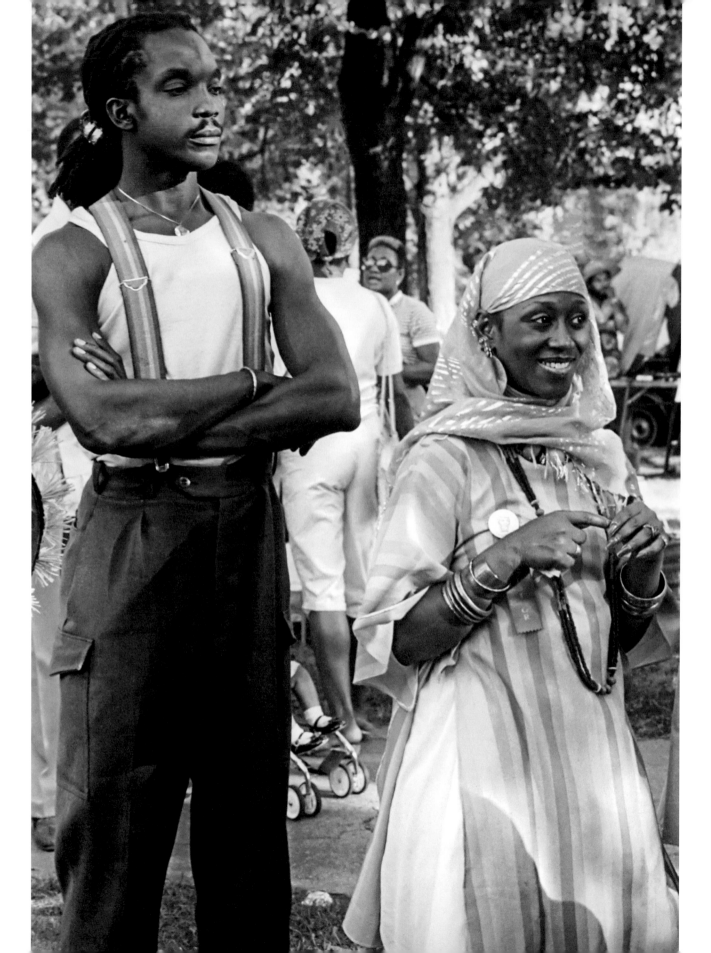

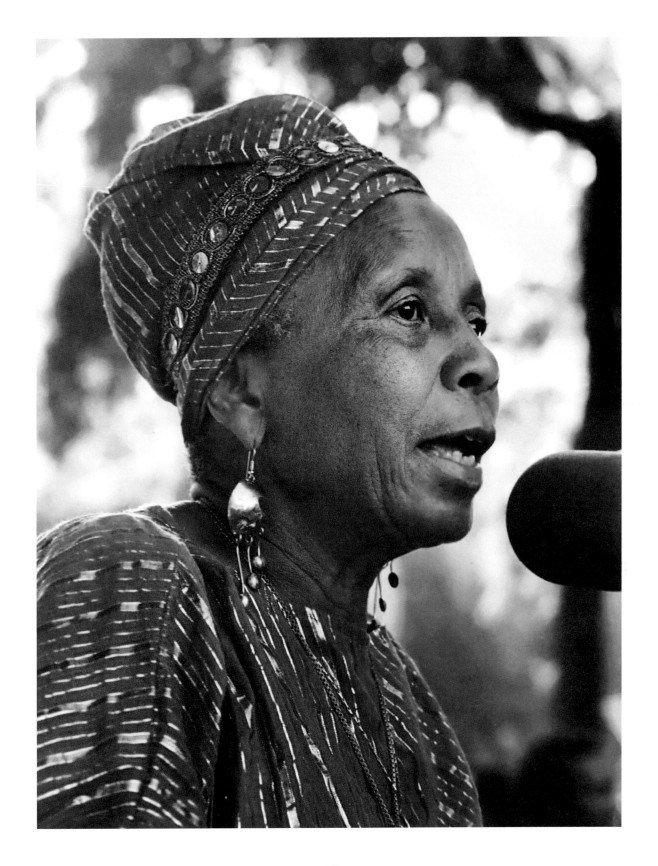

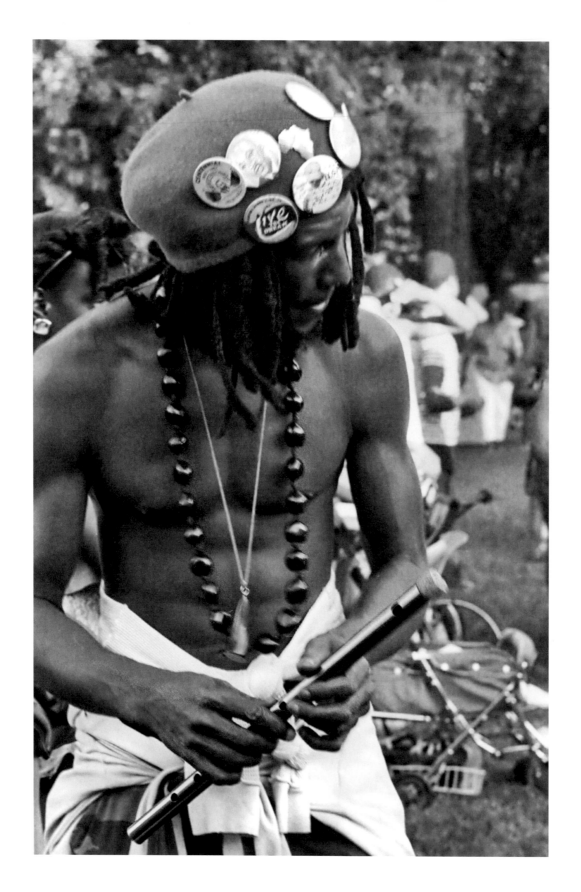

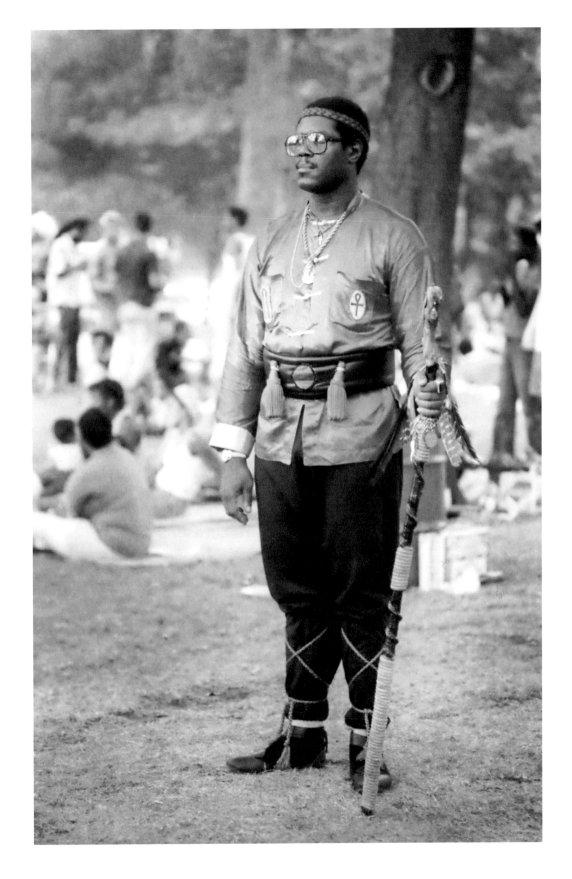

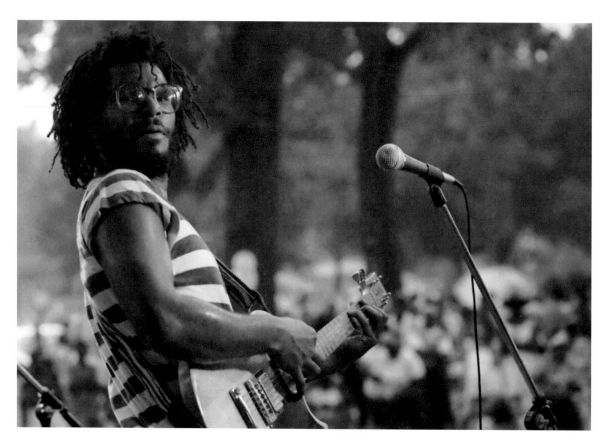

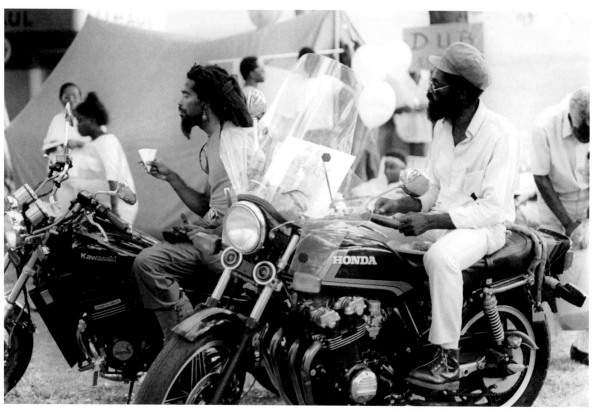

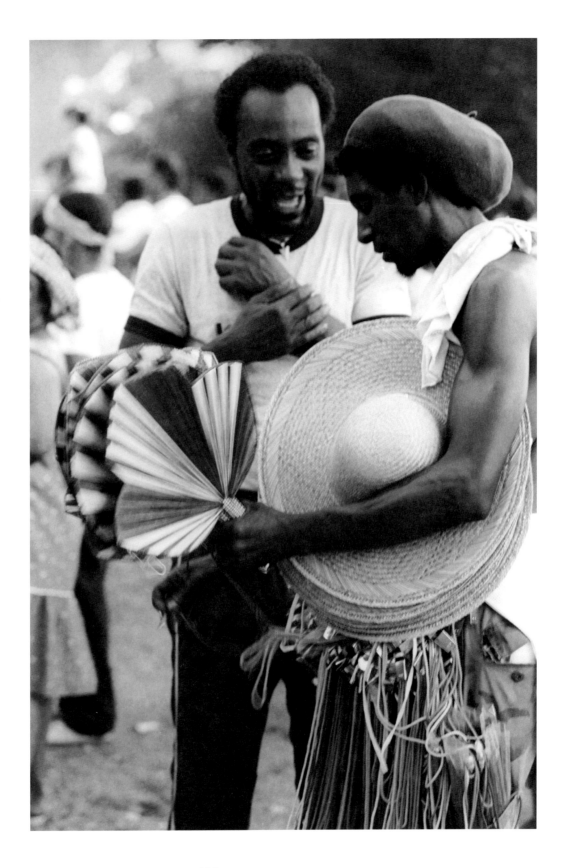

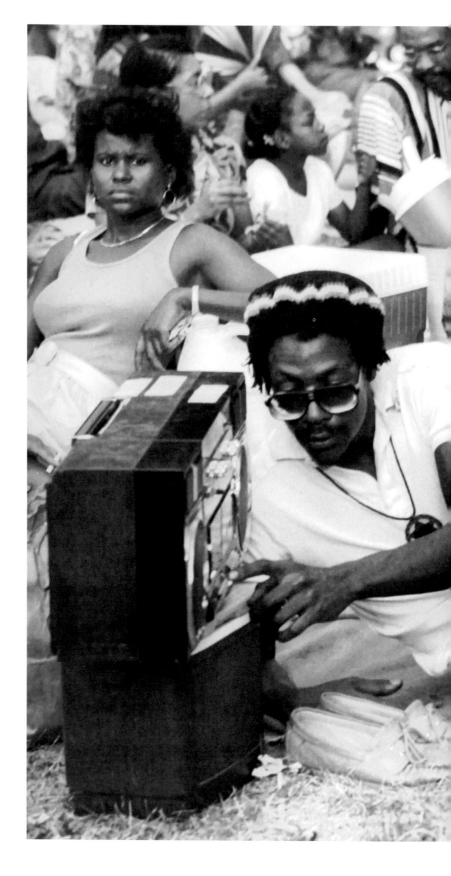

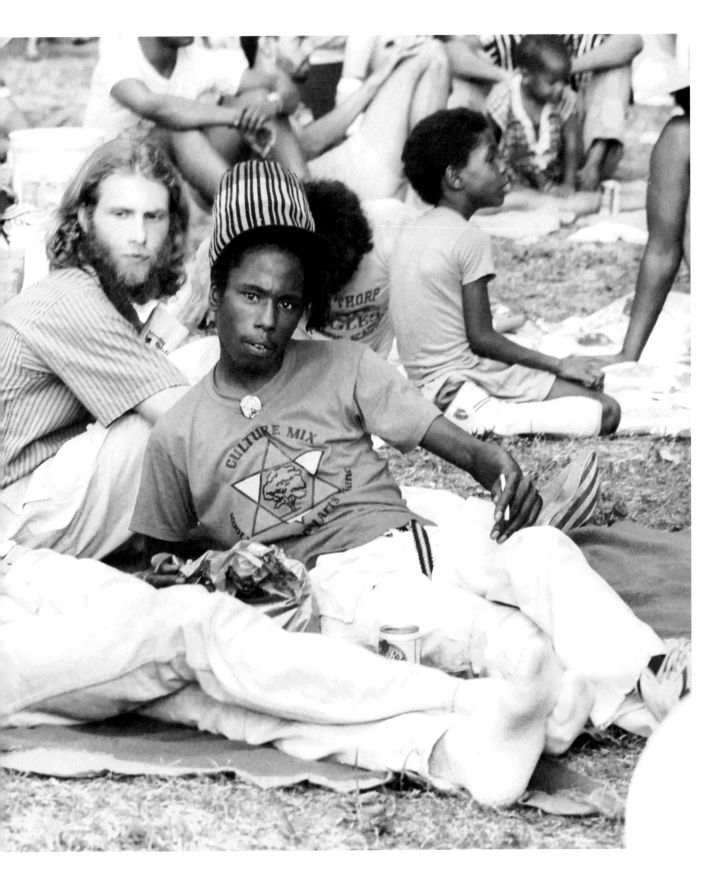

Children & Families

Our Kingdoms to Come

Children and Families in the Photography of Rose Blouin

Tracie D. Hall

This is our leadership
this is our kingdom to come
as it comes out of our hearts
to find strength in the common world.
We will raise it and develop it.
—**Amiri Baraka**, *In Our Terribleness*

From *Black Boy* to *Cooley High*, from *Hoop Dreams* to *There Are No Children Here*, the lived experiences of Black children and families have served as bellwether and litmus test for the well-being of the broader, national Black community. Certainly, we could have seen foretold in the balkanization and destabilization of Chicago's public housing and the gentrification of its Black neighborhoods three or more decades ago the devastating economic, employment, and housing losses that would grip Black communities, as outcomes in each of these areas improved or at least stayed the course for others.

Chicago's news headlines increasingly and by now expectedly lead with stories of crime and blight in Black neighborhoods, sowing fear and distress whenever incidents spill over into other areas, as if neighborhoods were separated by impenetrable walls. Correspondingly, Black children are more likely to be featured in a news story because they were caught in a crossfire than because they won a debate tournament or a prestigious scholarship to an elite music conservatory, or because they have fought for legislation to require Illinois schools include books by authors of color in all curricula, including summer reading lists—events that happen even more routinely.

Black children in Chicago, like Black children in Port-au-Prince, like Black children in Johannesburg, possess uncanny resilience. While they have not been spared the coldness of the world, they manage to maintain the courage and curiosity to embrace it. We

Tracie D. Hall, librarian and curator, is currently Distinguished Practitioner in Residence at the University of Washington Information School. Hall is former executive director of the American Library Association and past Deputy Commissioner of Chicago's Department of Cultural Affairs and Special Events. Deeply invested in the intersections of arts access, literacy, and socioeconomic mobility, Hall has worked on several initiatives integrating art with workforce development and public safety. Hall was the founding curator of the influential community art space, Rootwork Gallery and has been the recipient of numerous awards and citations for her advocacy and for her contributions to the arts, literary, and philanthropic communities.

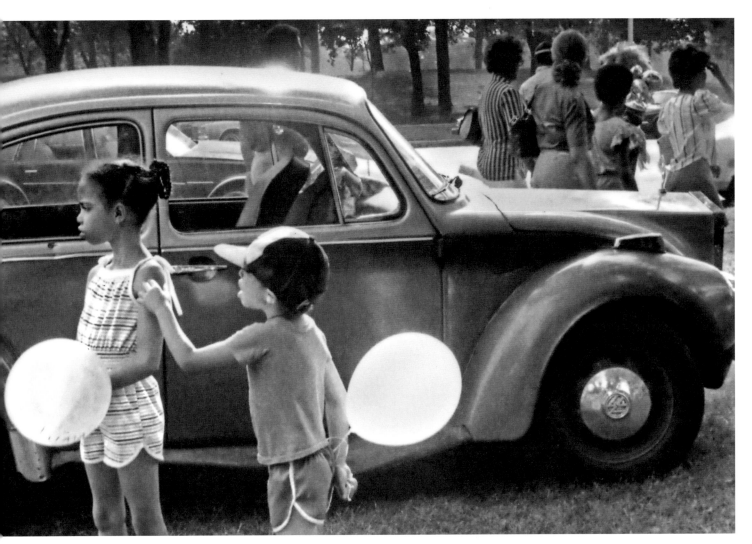

witness this tenacity and hunger to participate in life in Blouin's photographs of youth: a preteen boy waiting expectantly by a wrought-iron fence, a glint in his eye suggesting his appetite for adventure; young kids smiling wholly into the camera, their eyes suggesting discernment and, perhaps, wariness beyond their years.

Blouin's images of children with adults are even more compelling. They seem to ask, How do we protect our youth? What is our responsibility to allow them to enjoy and sustain the innocence of childhood as long as possible? The little girl peeking through her father's legs or another resting on her father's chest move us to ask, What is our collective responsibility to Black children?

Five decades earlier, in his part poetic manifesto and part meditation on Billy "Fundi" Abernathy's heart-grabbing photographs of Black Chicago, poet Amiri Baraka suggested how we answer that question bears existential consequences. Of a photograph of a young man, he declared, "This is our leadership. This is our kingdom to come . . . we raise it and develop it."

Blouin's photographs of children and families carry that same gravity, transfering the onus of the well-being of our young people and our communities onto the viewer. No one looking at these images is exempt from responsibility for these lives. Not you. Not me.

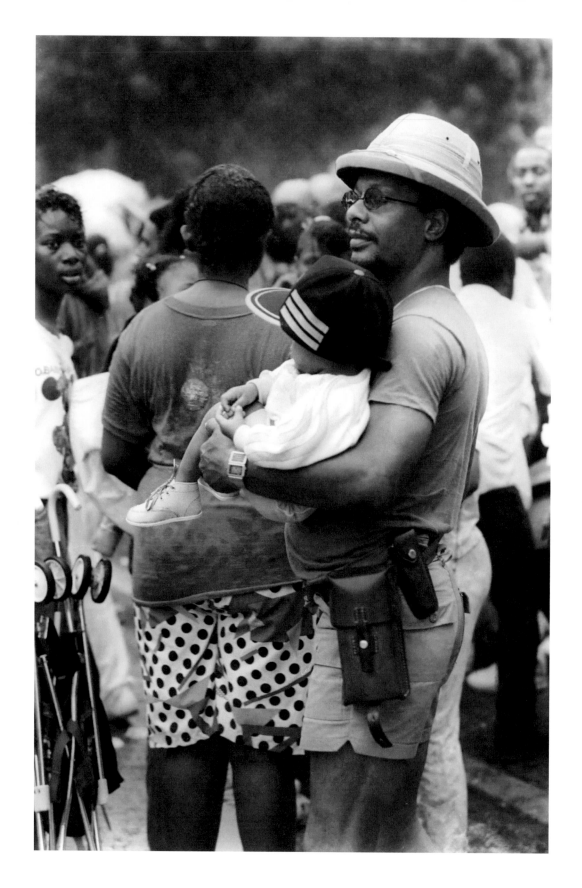

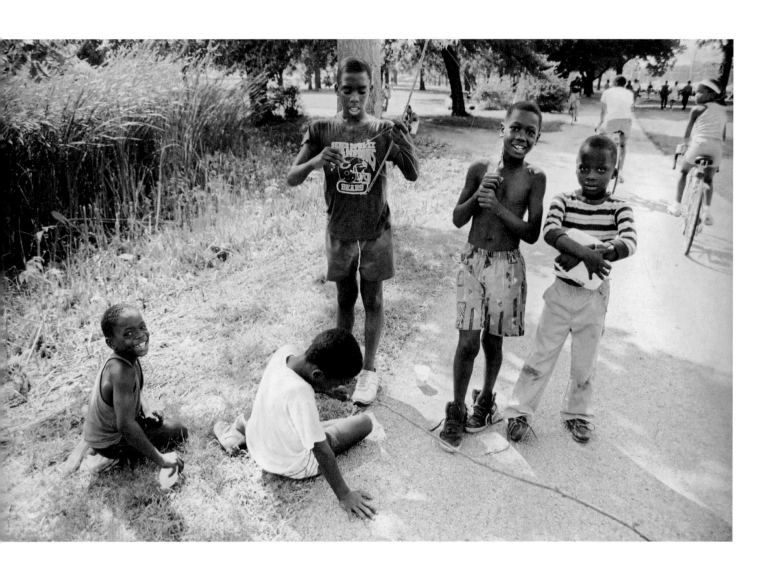

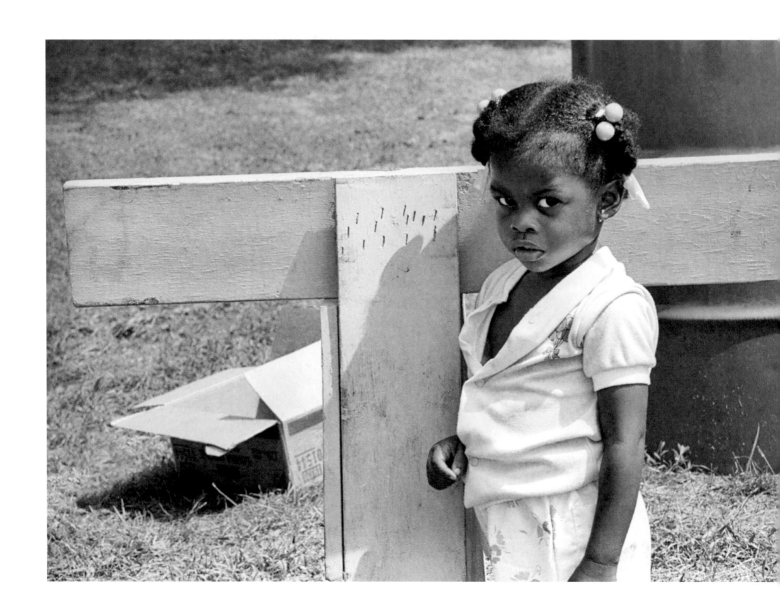

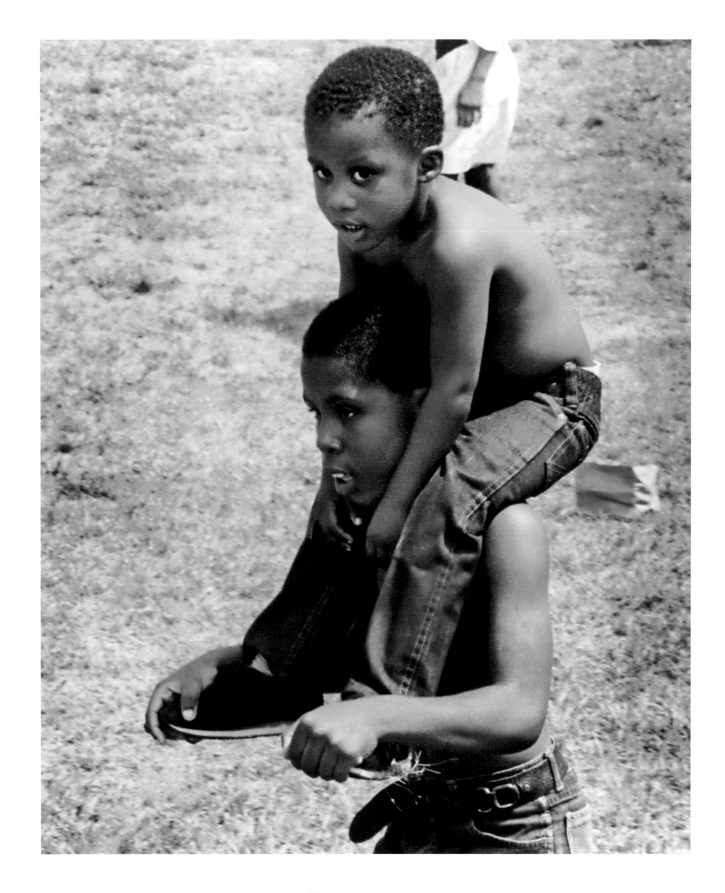

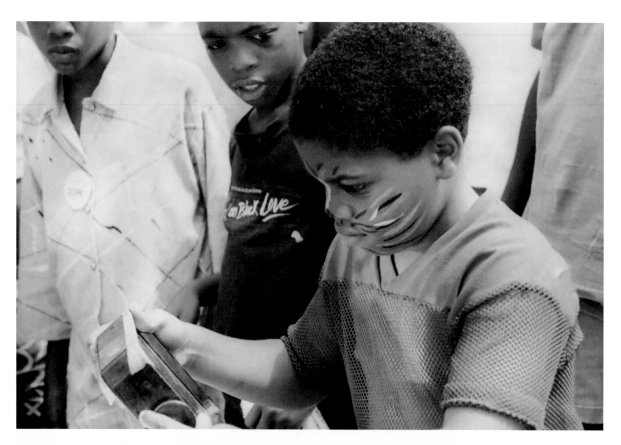

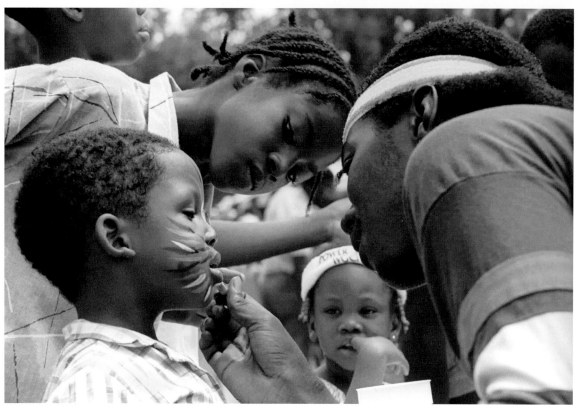

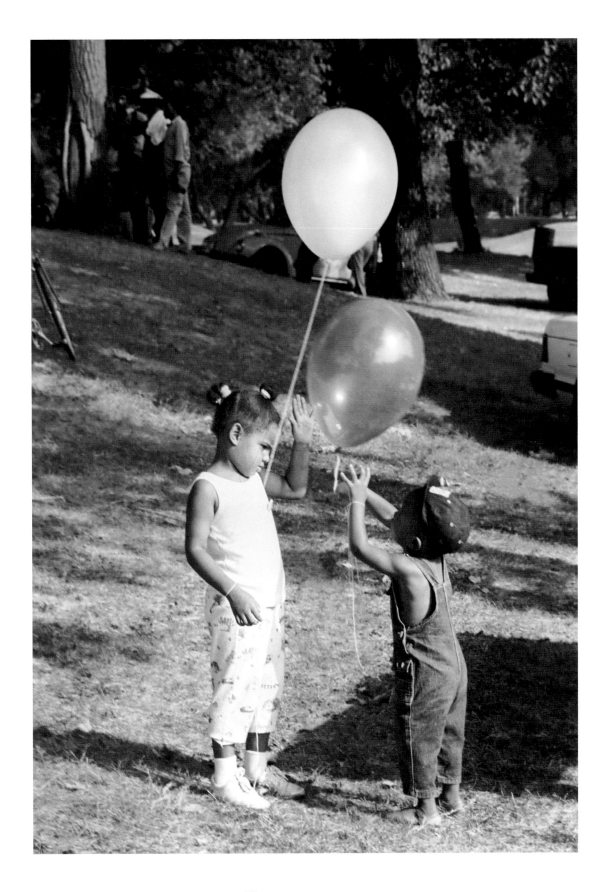

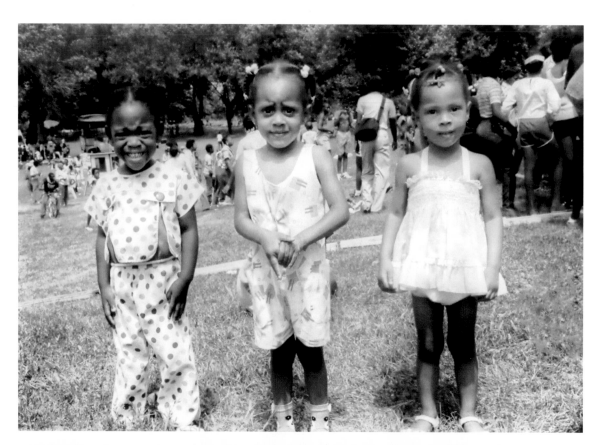

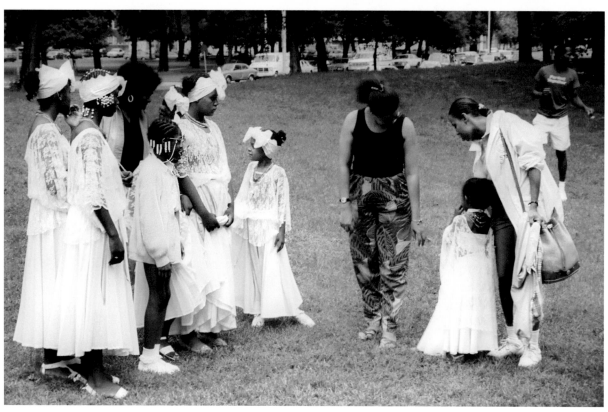

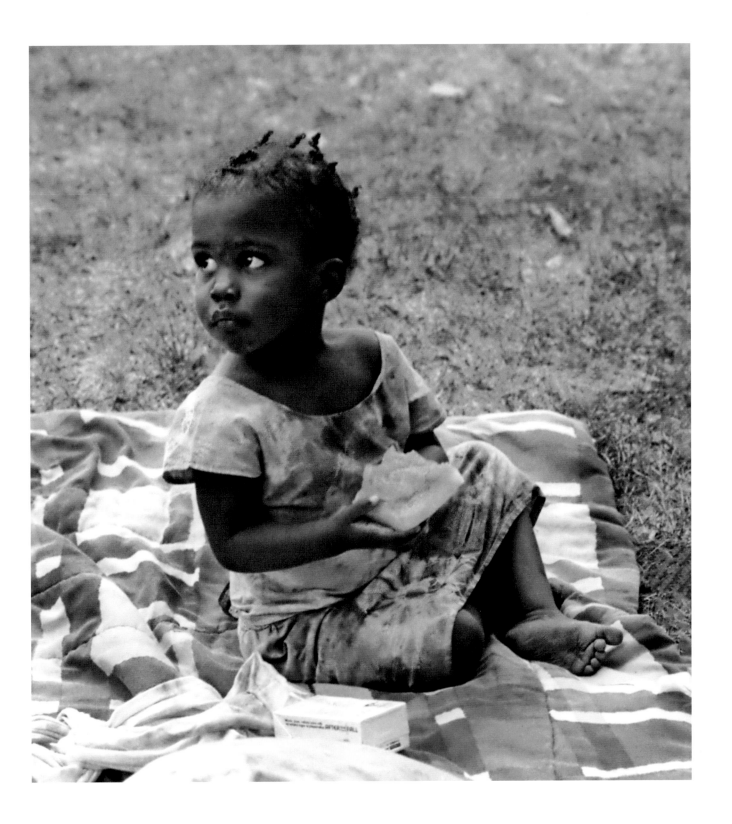

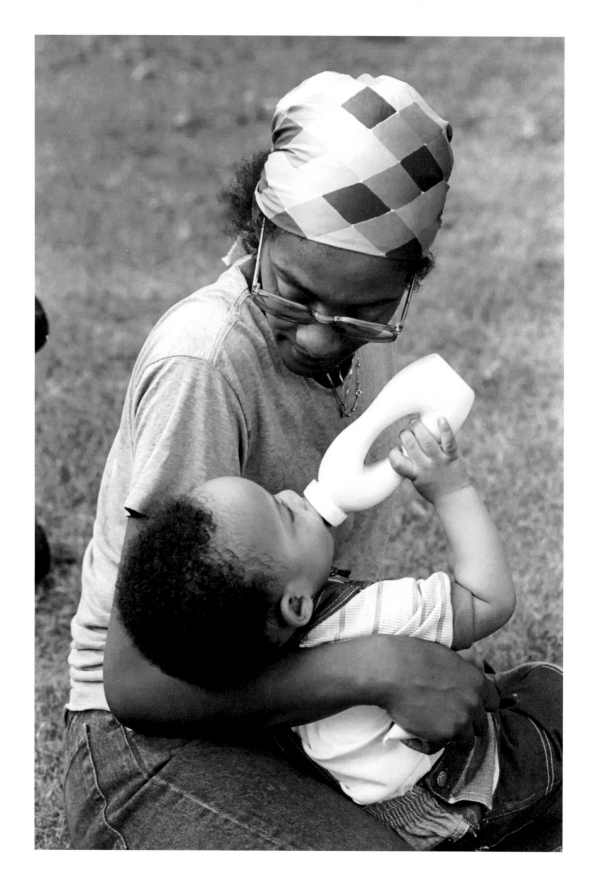

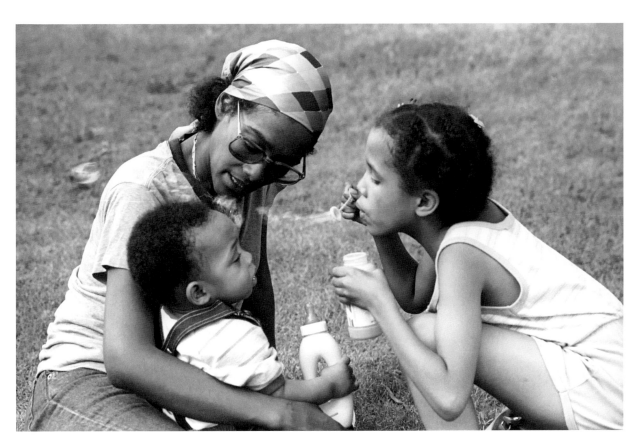

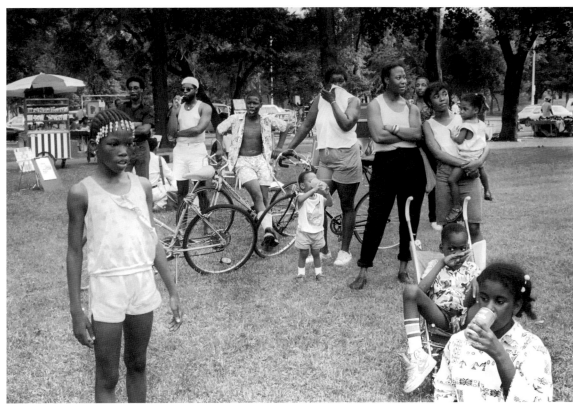

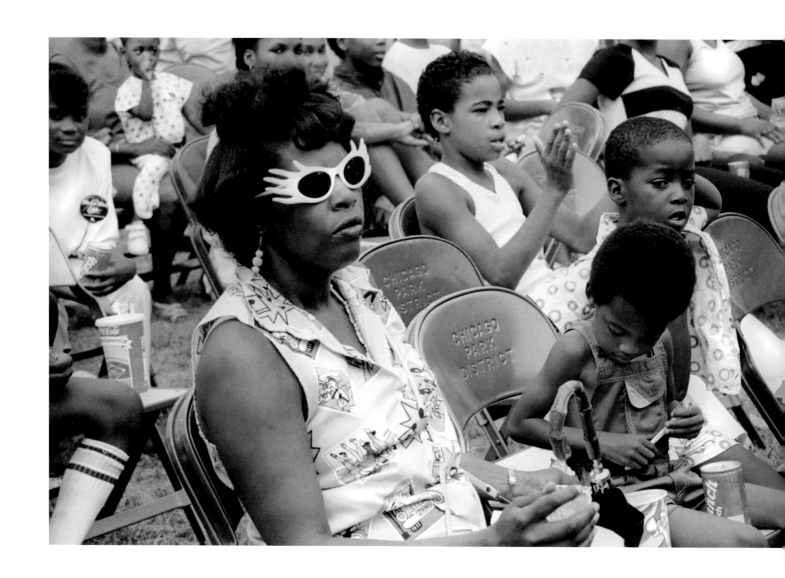

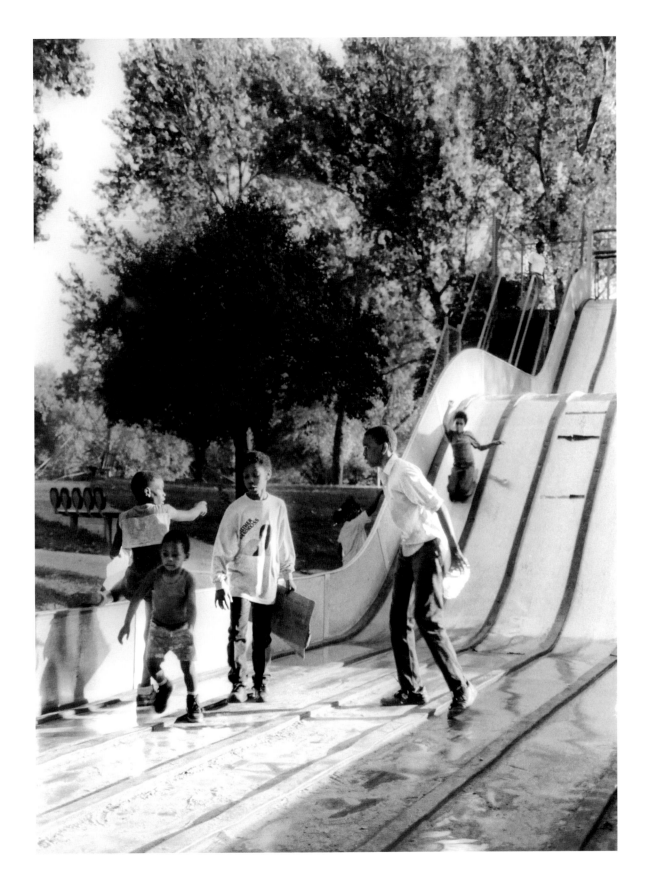

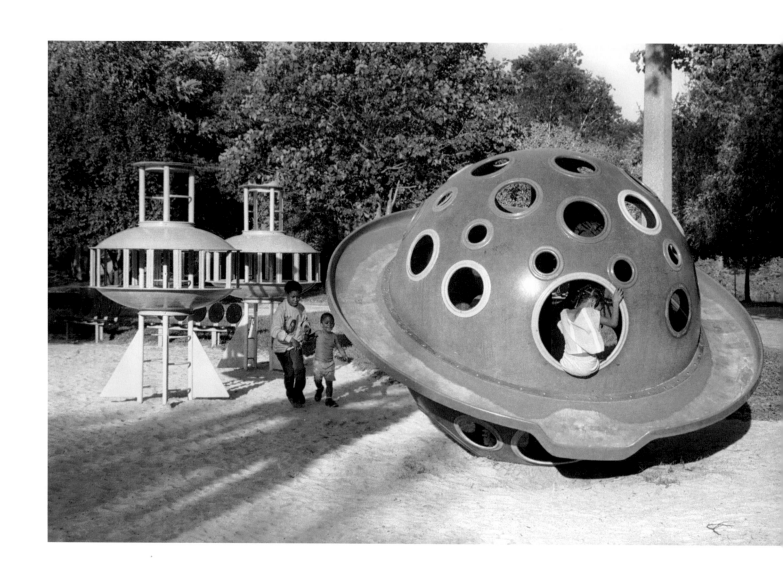

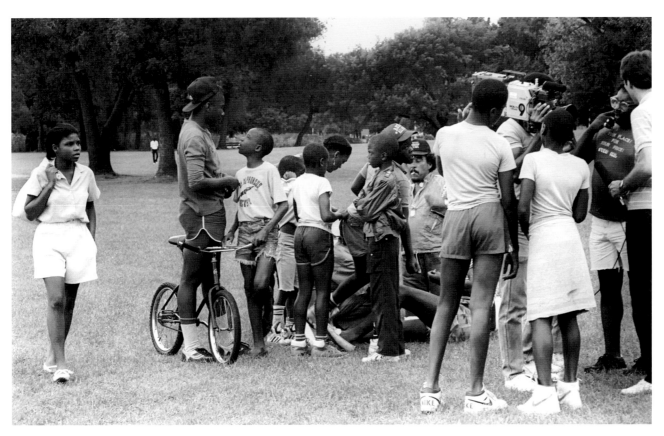

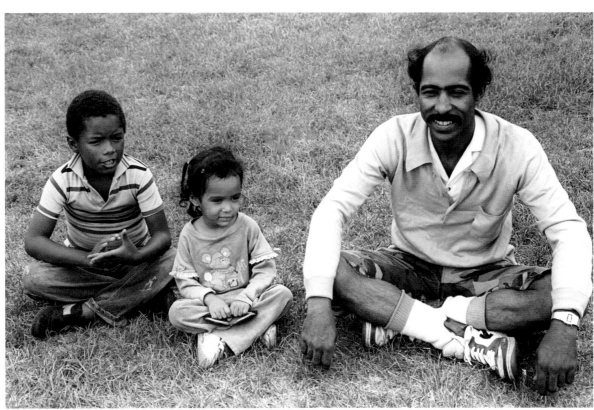

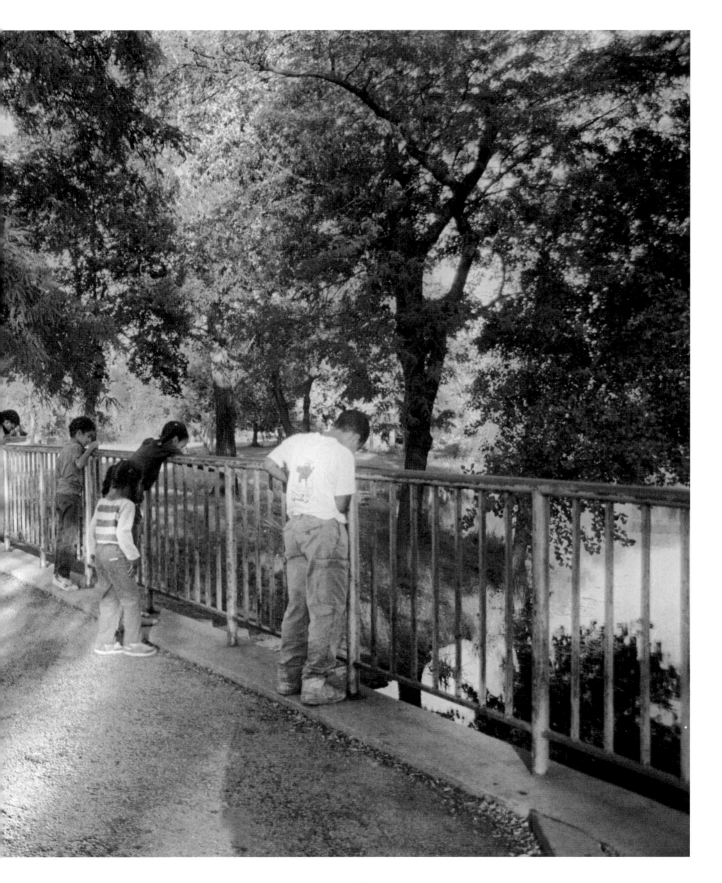

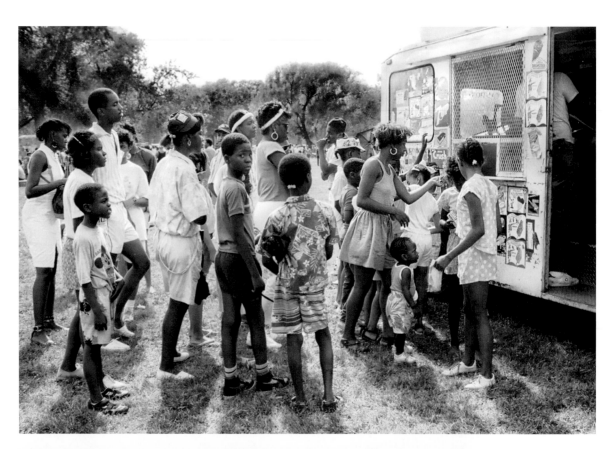

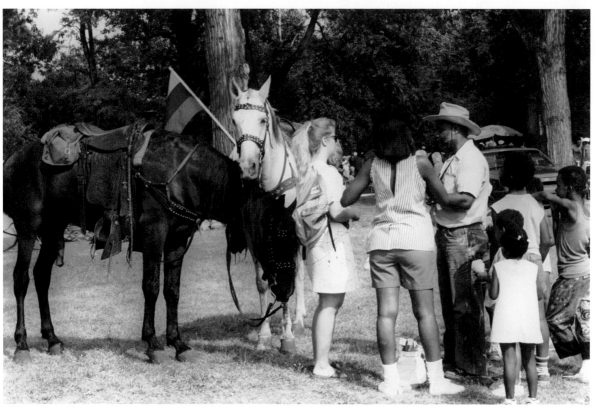

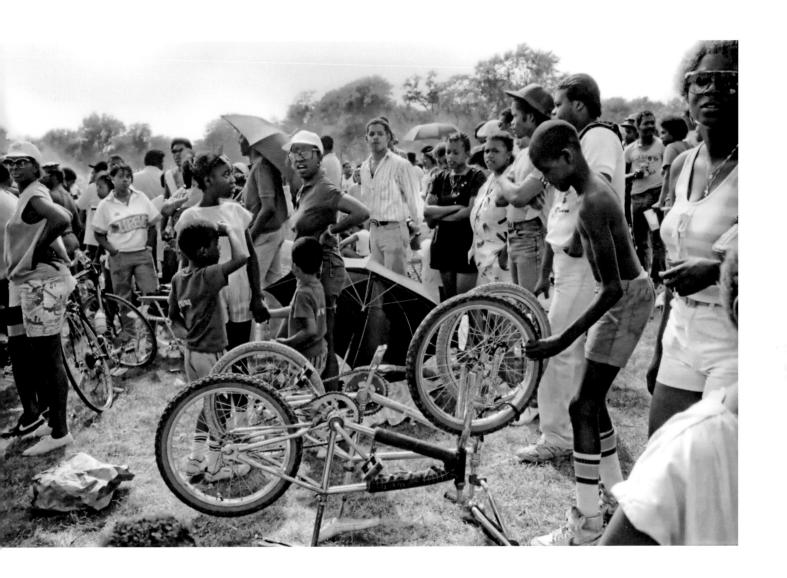

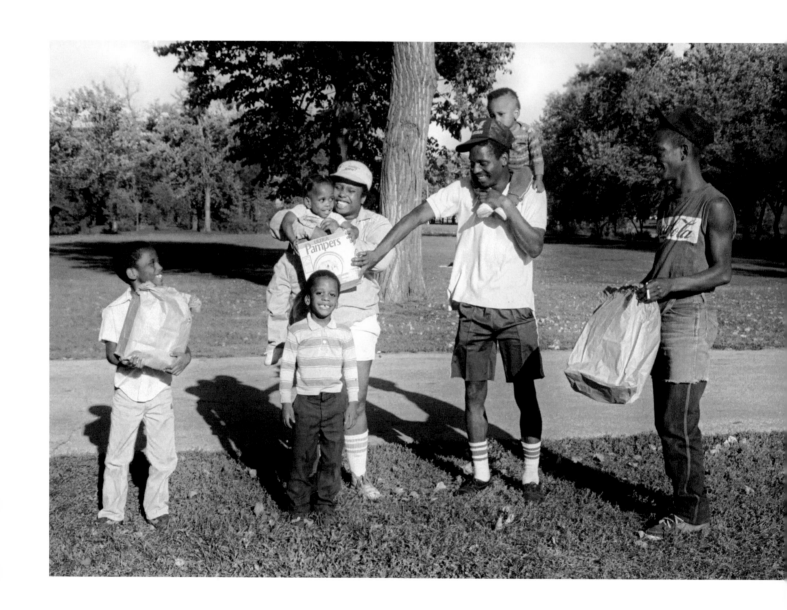

126

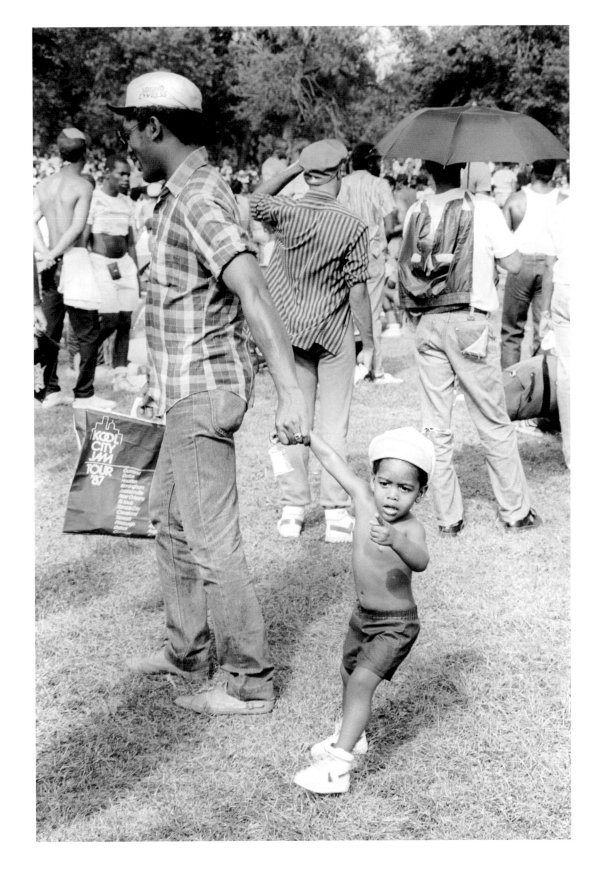

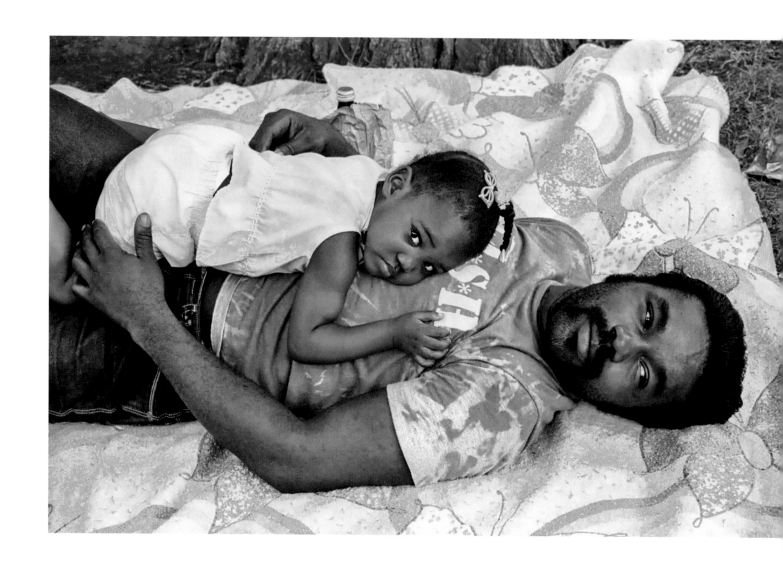

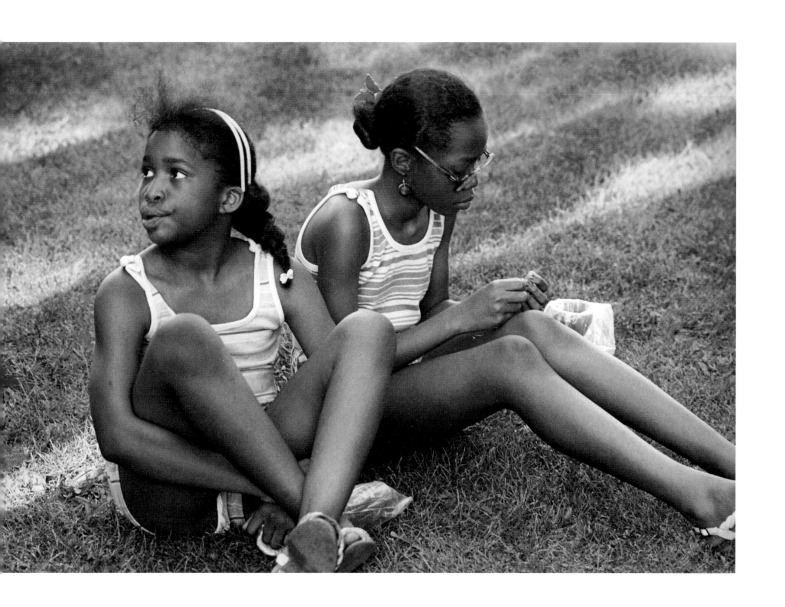

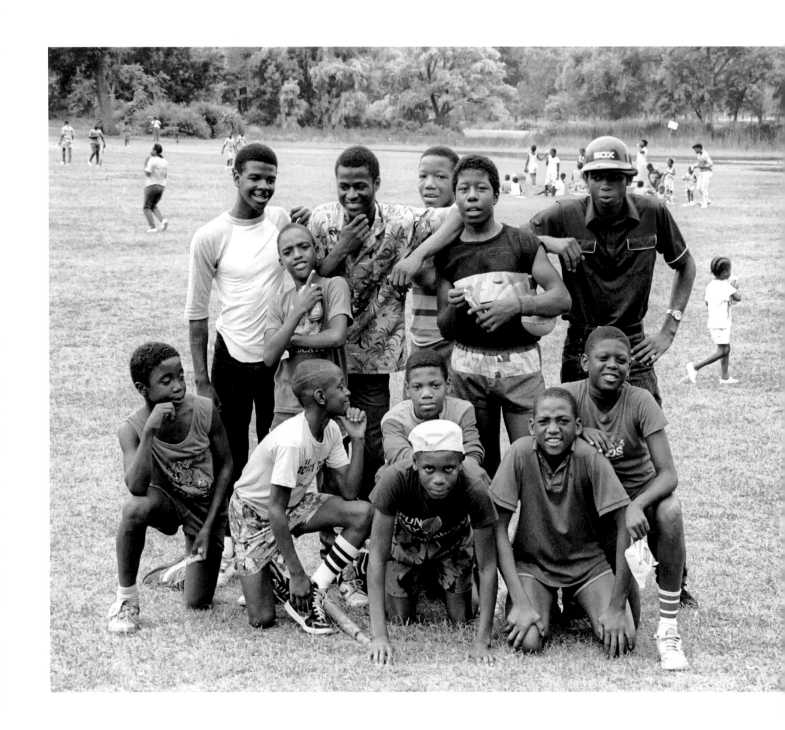

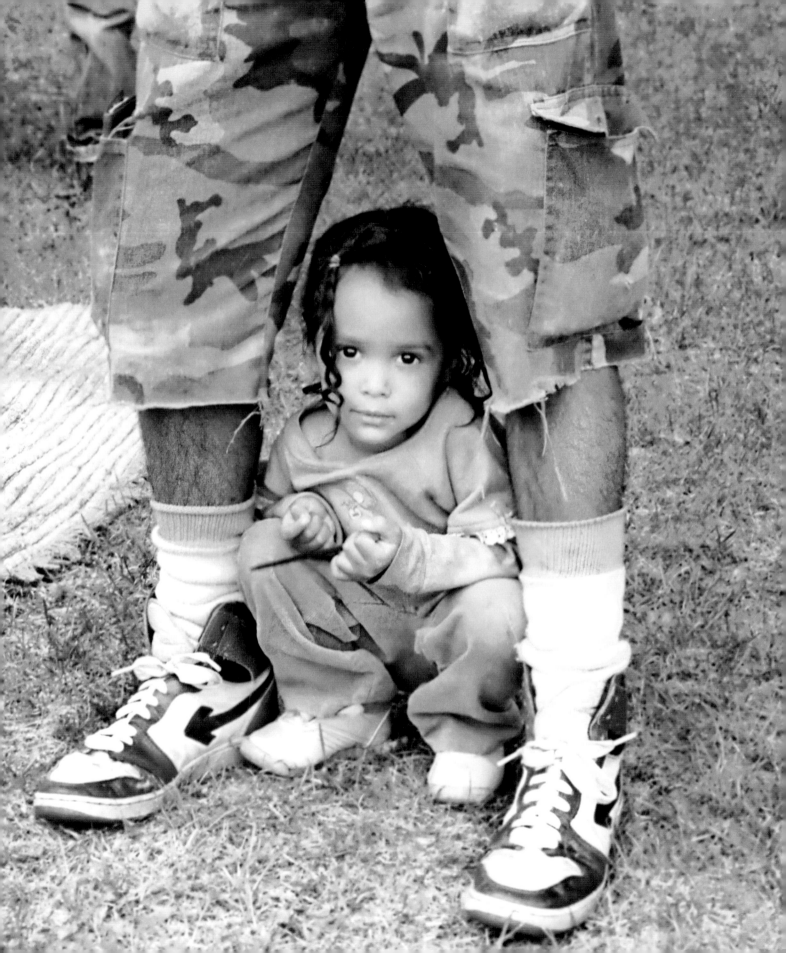

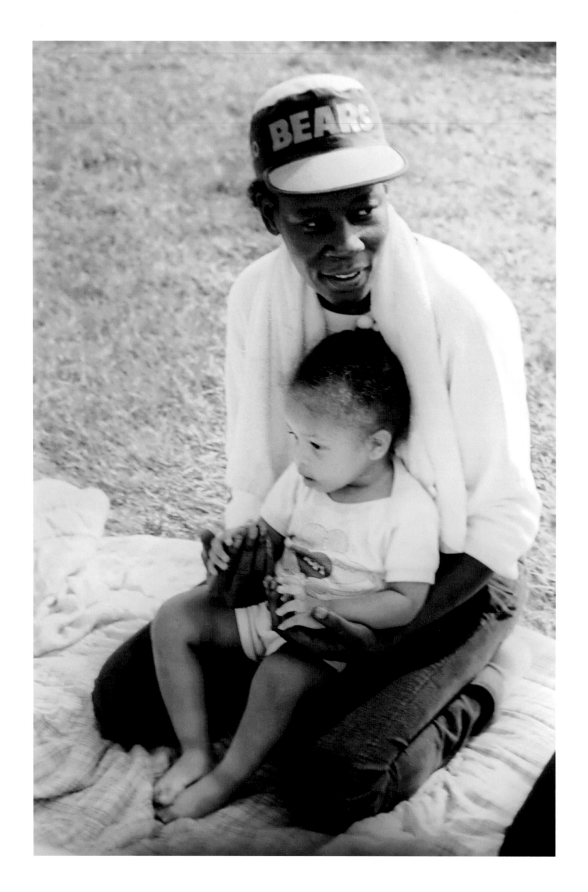

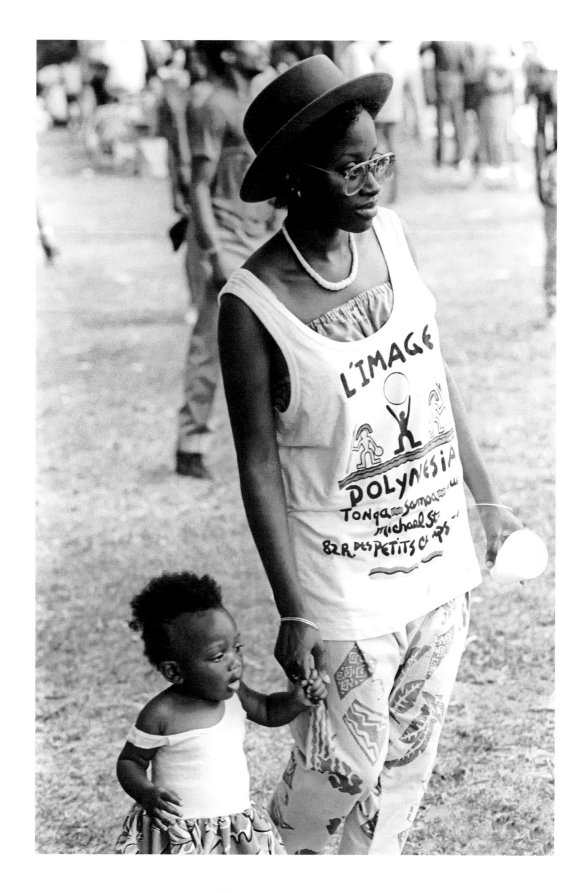

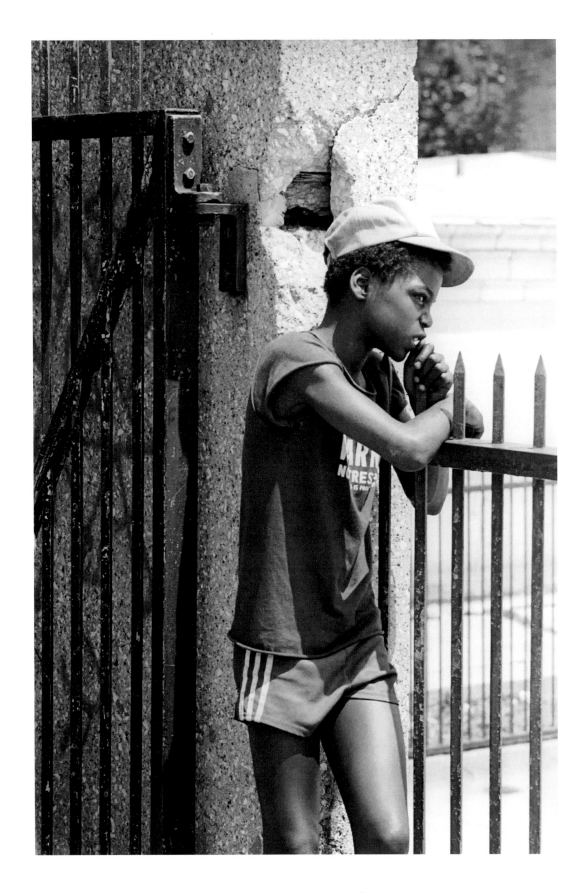

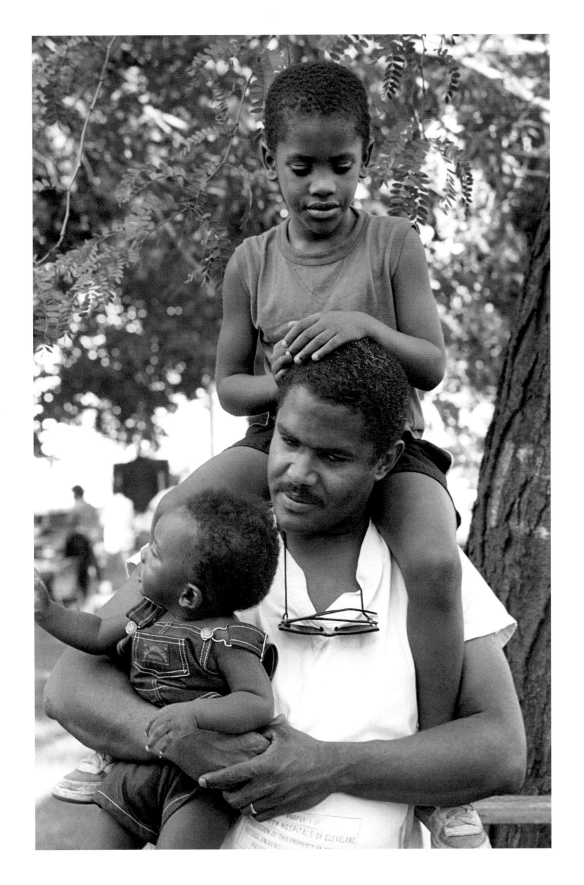

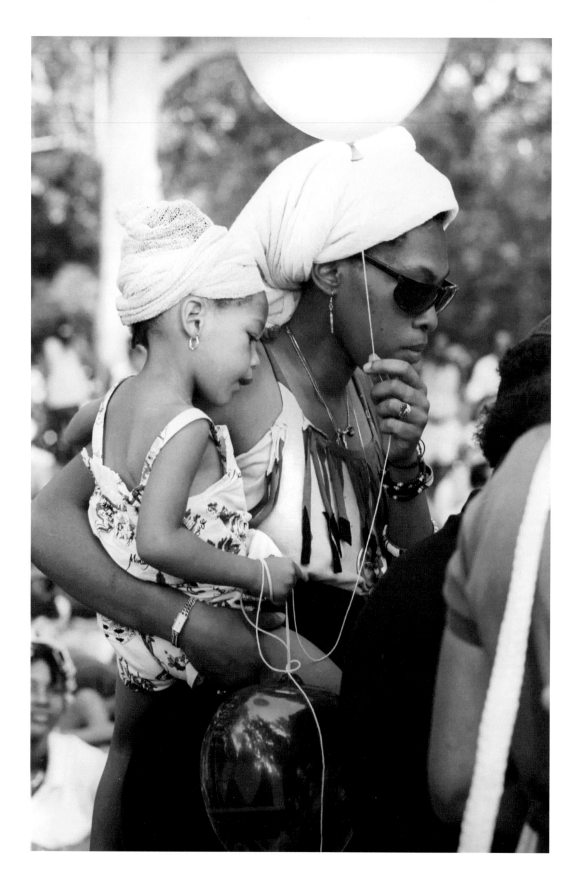

Afterword

A Soft Beckoning Closer to a Black Sublime

zakkiyyah najeebah dumas-o'neal

I'm compelled to engage with Black image-making practices as a tool to awaken and affirm Black being outside of the context of our traditional political responsiveness to the relationship between Black folks and politics of "the camera." How might this body of work encourage us to seek both solace and togetherness within the natural environment? What does it mean for the Black femme gaze to highlight ways of being that evoke the totality of Black life? How might the photographic image affirm the poetics of everyday life? My conviction and emotional response are that the Black photographic image holds the capaciousness to be a liminal space generating an aliveness and transcendence which is universal in its specificity. While I approach Rose's work with the politics of Black photographic agency in mind, I share what is purely my own subjective and inner engagement with her practice, and her voice which encourages a state of being that resides in the profound and the spiritual. Leading with these thoughts, please consider this:

What might reunification of Black thought with spirit entail? What miracles? What wonders? What avenues? What operations might such a reunification provide? Calvin Warren

Rose Blouin's intuitiveness toward image-making is anchored by her own sensibilities to the mundane, with an undeniable reverence for Black life and being. While the above quote suggests reunification in the context of political unity for Black folks, I'm interested in how the political reference here is interchangeable to that of a visual unity, accessible and possible through Rose's engagement with photographic making and constructing. Blouin's gaze is not only attuned and tapped into the quotidian beauty of Black folks, but her eye is attuned to the spiritual and somewhat intangible, her making activated by an impulse to shape meaning, which undeniably encourages us to slow down and look closely with *"a refined introspection,"* as she shared with me. During that summer of 1987, there is wonder in

zakkiyyah najeebah dumas-o'neal is a Chicago-based visual artist, educator, and independent curator. An Albertine Foundation Laureate awardee, her work has been presented in numerous galleries and museums. najeebah dumas-o'neal serves as the embedded artist for Senn High School as part of the Museum of Contemporary Art's SPACE program. She is also a cofounder of CBIM (Concerned Black Image Makers), a collective of lens-based artists of the Black diaspora.

137

Washington Park, and there is immense potential. Rose's naming of a refined introspection conveys her ability to mark her work with an emotional range and breadth of intimacy, being knowingly deliberate about *how* and *when* she conjures a frame, and how that conjuration calls us inward. I often think about the ways Black photography allows for a reframing of Black thought *and* Black feeling to activate avenues for not just introspection, but self and collective awareness. This innate and eloquent awareness, brought on by years of Rose's own determination and existential meditations, softly demands that we ask questions about our relationship to land, time, and togetherness.

Moreover, Blouin's keen eye for composition, space, and environment cultivate a quiet determination, immediately recognizable when I first encountered her photographs of Washington Park. This recognition is, in fact, a spiritual and historical awakening, expanding upon my capacity to be reinspired by a historical trajectory of Black image-making that most Black photographers in Chicago are indebted to. I was absolutely stunned that these images were not already at the forefront of my visual and mental catalog of Black photographic practices tied into the fabric of the Black Arts Movement and its counterparts. This determinative essence in her work is not passive by any means. Instead, it ushers in a quietness and a stillness that taps *in and out* of a pulse, activated by Black folks evoking a life force, that should be considered and disseminated as a necessary framing of Black collectivism on the South Side. The work is fluid and expansive for its time. Her gaze holds the past, present, and future, generously reminding us that the sublime, animated by *being* and *living,* through candid displays of love, joy, and leisure, can be found in a space such as Washington Park. A *Black sublime* only possible through Rose's attunement and assertion that there is eternal beauty in our people and any space we choose to inhabit. *How* we perceive ourselves, and *how* we're cared for at the center of the photographic gaze, suggests there's a necessity to imaging Black folks in natural environments, expressing an undeniable range of livelihood.

Through her photographs, Rose seeks to reveal not just moments in time but the underlying emotions and experiences that define them. In doing so, she gifts us a more nuanced and empathetic portrayal of Black existence. Drawing threads between her own reflections and the images themselves, I am reminded of the interconnectedness of all things, seen *and* unseen, and the symbiotic relationship between people, landscapes, and memories. Coming to terms with such image-making provokes my own relationship to the geography of the South Side, and the spaces I feel compelled to carry myself. I fully believe lush public parks and the lakefront are the few spaces that allow for accessible, but liminal, liberatory experiences within our urban landscape and beyond.

After several encounters with Rose and her work, I have come to understand that she upholds her photographic practice as a sacred space. That sacredness is located and felt within her careful consideration of the natural environment, provoking the will to think differently about how Black folks are situated within time and space. Through her gaze, the landscape of the park feels like a space, a sanctuary, and an inheritance. Black folks can reclaim themselves and assert their presence in the world, not solely restricted to the South Side, but as if they could be anywhere *and* elsewhere. In this sense, her practice transcends documentation; it becomes a vessel and transmission for communion, inviting us to participate in a shared exploration of the sublime, which can't always be named *or*

identified. Her work brings about a soft beckoning, motivating us to get close and near and, once close enough, submit ourselves to *feeling* and *experiencing* the range of her work.

Toni Morrison's literary work is incredibly true to the culture of the Black South and the people I know. I was looking for that same imagery in the world. Rose Blouin

At the heart of Rose's "impulse to create" lies a delicate balance between the ordinary and the magical, a convergence that infuses her work with a sense of timelessness and wonder. Drawing inspiration from the tradition of magical realism and Toni Morrison's reconfiguration of the genre, she invites anyone compelled to do so to explore the ephemeral moments of everyday life, extending grace to anyone within the frame of her visual consciousness. It is in the everyday, for Rose, where the mundane becomes infused with a sense of the extraordinary. In her photographs, seemingly ordinary scenes are transformed into portals of transcendence, inviting us to contemplate the deeper meanings hidden within. This is a poetic mirroring of Rose's constant search for meaning, as she's an avid journal writer, often reflecting on her mundanity and existential ruminations. In her depiction of Washington Park, the landscape itself becomes a site for contemplation, visually highlighting not only the physical beauty of the environment, but intensely reflecting her memories of the southern landscape. "I have a love affair and connection to nature in the South," she reflects, acknowledging the profound impact that the landscape has had on her visual and artistic sensibilities. "I knew right away that I wanted the landscape to be a subject in and of itself." Through her own nostalgia, sentimental and sensitive, Rose's devotional attention to the ephemeral beauty of ordinary moments transcends materiality and place. This convergence creates a Black space where convening *and* leisure are constructed as a place of reverence and significance. In this space, ordinary people engage in acts of living and being that defy assumptions and, at its most profound, offer infinite interpretations for transcending the confines of limited understanding of Black folks and our interconnectedness. Within Rose's visual and spiritual perception, the totality of our humanness is precious and magnified.

At the depths of Rose's inner eye lies a sense of self-assuredness and confidence, nurtured by a lifelong commitment and dedication to her craft, and the pure gratitude of documenting Black life. Despite the challenges and uncertainties that can accompany a photographic trajectory, she remains steadfast in her belief in the power of photography to illuminate the world, *our* world. "I always felt good about my creative expression," she affirms, acknowledging the intrinsic value of her capacity to transcend the medium of photography altogether.

Acknowledgements

Haymarket Books staff including Julie Fain, Eric Kerl, Rachel Cohen, Aricka Foreman, and Jameka Williams.

This project would not have been completed without the initial assistance of an Individual Artists Program Grant from the City of Chicago Department of Cultural Affairs & Special Events, as well as a grant from the Illinois Arts Council Agency, through federal funds provided by the National Endowment for the Arts.

University of Chicago Arts + Public Life staff for curating and mounting the exhibition "To Washington Park, With Love," and special thanks to curator, Kate Schlacter.

Eve Ewing and Adrienne Brown, who have supported the creation of this book since their first viewing of my Washington Park photographs.

Writers Lee Bey, Romi Crawford, zakkiyyah najeebah dumas-o'neal, Tracie D. Hall, Salim Muwakkil, and Angela Jackson.

Colleen Keihm, Executive Director of LATITUDE Chicago for invaluable support.

The women of Sapphire & Crystals, an African American women's art collective; as a cofounder of this collective, I have enjoyed the support and inspiration of these incredible artists since our beginning in 1987.

Rose Blouin, Photographer

roseblouinphotography.com

Rose Blouin has worked in the medium of photography since 1980.
Photographic areas of particular interest include fine art and documentary work.

Exhibitions & Awards

Focus & Click, invitational exhibition featuring Susan Aurenko, Rose Blouin and Paula Chamlee, Art Center Highland Park, 2024.

Black Creativity," juried, Museum of Science & Industry, Chicago, 2024, 2022, 1991, 1990; Honorable Mention, 1989.

Sapphire & Crystals: African American Women Artists Collective, group exhibitions:

Freedom's Muse, University of Chicago Logan Center for the Arts, 2023.

Forward, Bridgeport Art Center, Chicago, 2022.

Looking Forward with Love: Lessons Learned From Our Past, a Sapphire & Crystals Retrospective, South Side Community Art Center, 2018.

Remembering Marva, South Side Community Art Center, Chicago, 2013.

Sapphire & Crystals, Prairie State College, 2013.

State of Grace, Woman Made Gallery, Chicago, 2012.

Postcard Show and Friendships, South Side Community Art Center, Chicago, 2010.

Visions, Elmhurst College, 2010.

Beyond Race and Gender, Noyes Cultural Arts Center, Evanston, IL, 2009.

Routes to Roots, Nicole Gallery, 2009.

Black, White & Blues, Woman Made Gallery, 2005.

Rites of Spring, Fourth Presbyterian Church, Chicago, 2005.

Sapphire & Crystals: In Black & White, Concordia College Gallery, River Forest, IL 2004.

From Within, South Shore Cultural Center, Chicago, 2003.

Tribute to Women's History Month, South Shore Cultural Center, Chicago, 2002.

Gods, Goddesses, Heroes and Mentors, Chicago Artists Month Exhibition, ARC Gallery, Chicago, 2001.

Reconnections, Union Street Gallery, 2001.

Issues of Identity, Satori Fine Art, 1995.

The Way My Mama Did, BAGIT Gallery, Chicago, 1994.

Images, Wood Street Gallery, 1993.

Divining: Sapphire & Crystals, Artemisia Gallery, 1992.

Sapphire & Crystals Too, The Nicole Gallery, 1988.

Inaugural Exhibition, South Side Community Art Center, 1987.

Black and White, Juried Exhibition, Sacramento Fine Arts Center, 2023.

The Promised Land: Eleven Artists Consider Black Life Through Migration, City Life, Portraiture And Family Archives, invitational exhibition, South Side Community Art Center, 2023.

To Washington Park, With Love, solo exhibition, University of Chicago, Arts + Public Life Arts Incubator, Chicago, 2022.

Washington Park Summer 1987 Series, Arts Lawn Banner Installation, Arts + Public Life and the Office of Civic Engagement at the University of Chicago, Juried, 2021.

Chicago Jazz & Blues: A Photographer's View, Logan Center for the Arts, Chicago 2019, 2015 (Honorable Mention for Best Photograph Taken at a Performance Hall).

Flowers in the Garden: A Tribute to the Struggles and Triumphs of Black Women, South Side Community Art Center, 2019.

Cuba Si! Bloqueo No!; Looking at the Revolution, Invitational Exhibition, Uri-Eichen Gallery, Chicago, 2017.

50 x 50 Invitational / The Subject is Chicago: People, Places, Possibilities Exhibition, Chicago Cultural Center, 2017.

Annual Beverly Arts Center (BAC) Art Competition, Juried, 2015, 2016, 2017.

Photographs of Havana, Solo Show, The New Studio Gallery, Evanston, 2016.

Bridgeport Art Center Annual Art Competition, Chicago, 2022, 2016.

Sankofa - The Female Urge, a limited run, invitational exhibition celebrating the woman artist and Women's History Month, Little Black Pearl Gallery, Chicago, 2008.

Heart of South Africa, solo exhibition, Ferguson Gallery, Concordia University, 2006.

Two Photographers: Rose Blouin and Eseti Ray, ETA Creative Arts Foundation, Chicago, 2002.

The Literary Impulse: Works Inspired by Writers of the African Diaspora, group exhibition, The King Arts Complex, Columbus, OH, 1997.

Flashes of Independence: A Photographic Interpretation of Black Life in America, five photographers, BAGIT Gallery, Chicago, 1994.

Seeing with the Inner Eye, Chicago Women's Caucus for Art, juried, 1993.

Three Rivers Arts Festival, juried, Pittsburgh, 1993.

The Merwin Gallery, Exhibition of four African-American Women Artists, Illinois Wesleyan University, Bloomington, 1993.

Contemporary Photography (three photographers), Isobel Neal Gallery, Chicago, 1993.

Black Fusion, juried exhibition, ARC Gallery and North Suburban Fine Arts Center, 1991.

Our Fathers, Our Brothers, Our Sons..., a juried artists' billboard project coordinated by The Randolph Street Gallery, Chicago, Photographic collage mounted at three outdoor billboard sites in Chicago.

The Art of Jazz, group photo exhibition, Chicago Jazz Festival, Grant Park, 1987; traveling exhibition, 1987-89.

Eighth Annual Black Artists' Exhibition, juried, The J. B. Speed Art Museum, Louisville, Kentucky, 1987.

Annual Atlanta Life National Art Competition and Exhibition, juried, Atlanta, 1987, 1988.

Roots: A Contemporary Inspiration, juried, Evanston Arts Center, 1986; Illinois traveling exhibition, 1986-88.

DuSable Museum of African American History Annual Art Fair; two purchase awards, 1986.

Independence Bank of Chicago, group exhibition, 1986.

Axis Photo Gallery, solo exhibition, Chicago 1986.

Women Against Racism Conference, group exhibition, University of Iowa, 1986.

Milwaukee Inner City Art Fair; Excellence Award, 1985.

Moments in Time & Space, 2-person exhibition, Institute of Positive Education, Chicago, 1985.

Partial List of Documentary Commissions

Chicago Historical Society, Opening Gala and Sojournor Mentoring Program in conjunction with *I Dream A World* Exhibition

American Airlines, Inc.

Golin-Harris Communications, Inc.

McDonald's

Akosua Designs, Inc.

City of Harvey, IL, Chinese Mayor's Delegation, US Tour

African-Caribbean Bookstore, James Baldwin Appearance

Minority Institutions Science Improvement Project (MISIP) Conference

Illinois Dept. of Alcoholism & Substance Abuse (DASA) Conference

National Conference of Artists' 25th Anniversary Conference

Ed Wilkerson, Dee Alexander, studio recording sessions

Secret of the Magic Cloth, children's film project

Third World Press 20th Anniversary Celebration

Publications

A Week In Havana: Photographs by Rose Blouin, 2023.

Hyde Park Herald, "In new Arts Incubator show, 35-year-old photos of Washington Park see the light of day," Christian Belanger, editor, *Feb 17, 2022*.

Revise the Psalm, the Gwendolyn Brooks Anthology by Curbside Splendor, 2017, eight photographs of Gwendolyn Brooks included.

"Midnight Blue," *Blue Lyra Review, Spring, 2014*.

"Blues Corridor," *Blue Lyra Review, http:// bluelyrareview.com/issue-2-2/*, Summer, 2013.

South Side Stories, City Stoop Press, 1993; cover photo.

Columbia Poetry Review, Columbia College Chicago, 1991; cover photo.

Say That the River Turns: The Impact of Gwendolyn Brooks, Third World Press, Chicago, 1987; photo of Brooks included.

Killing Memory, Seeking Ancestors by Haki Madhubuti, Lotus Press, 1987; cover photo.

The Chicago Musicale, September, 1986; cover and text photos.

Menagerie, Chicago State University Literary
 Magazine; cover and text photos, 1986, 1987.

Film & Video
NBC Chicago, "Celebrating Women's History: 'To
 Washington Park, With Love' Exhibit Now
 Open," Lee Ann Trotter, reporter, 2022
"Art & Design in Chicago: The Black
 Metropolis of Art," Interview and included
 photographs, WTTW Chicago, 2018

Grants
Individual Artists Program Grant from the
 City of Chicago's Department of Cultural
 Affairs & Special Events, 2021, 2019.
Activate History Micro-Grant, Illinois
 Humanities Council, 2020.
Chicago Artists Coalition SPARK Microgrant Award, 2019.
Illinois Arts Council, Special Artist's Assistance Grant, 2006.
Faculty Development Award, Columbia
 College Chicago, 2004.
Chicago Council on Fine Arts, Community
 Arts Assistance Grant, 1987.

Panelist/Juror
2020 Individual Artists Program grant review visual
 art/design panel for the Department of Cultural
 Affairs and Special Events (DCASE).
Creativity and the Environment, Columbia
 College Chicago, 1994.
Black Creativity, Museum of Science & Industry,
 Black Photographers Panel, 1993.
Art & Spirituality panel, Women's Caucus for Art,
 Chicago Chapter, Chicago State University; 1993.
Community Arts Assistance Program, Chicago Office
 of Fine Arts; Photography/Film/Video Panel
 Member, 1989; Visual Arts Panel Member, 1990,
 1991; Photography Panel, 1993; Chair, 1992.

Juror, South Shore Bank Photography Contest
 for High School Students.
Self-Definition, Sapphire & Crystals, panel
 sponsored by Chicago Women's Caucus
 for Art and Artemisia Gallery, 1992.

Presentations
Zoom Presentation on Documentary Photography:
 Washington Park, South Africa, Havana; Mather, 2020.
Project Innovation Workshop: Documentary
 Photography, SkyArt, Chicago, 2019.
"Artist Talk: A Taste of Havana," New
 Studio, Evanston, 2016.
Photography/Journal Workshop, CYC/Elliott
 Donnelley Center, 2006, 2007.
Art and Spirituality in Nature, Interdisciplinary
 Forum on Creativity and the Environment,
 Columbia College, 1996.
Assessing Contemporary Images: Viewing Our Society,
 Manley High School Arts Project, 1993.
Viewing Photographs, docent training presentation,
 Chicago Historical Society, 1991.
"A Flash In Time," photography workshop for
 children, Chicago Historical Society, 1991.

Collections
Parkways Community Center; DuSable Museum of
 African American History; Kay and John Wilson;
 The Lakeside Group; Bill Michel, Isobel Neal;
 Martin R. Cohen; Abena Joan Brown Estate; Faheem
 Majeed; Patric McCoy; Amina Dickerson; Peter
 Cassel; Adrienne Brown; Eve L. Ewing; Tracie D.
 Hall; and University of Chicago Medical Centers.

Rose Blouin has been a self-taught photographer of documentary and fine art images since 1980. She has shown work in solo, invitational, and juried exhibitions throughout Chicago's metropolitan area and beyond. In addition to Blouin's career in the arts, she was an associate professor in the English and Creative Writing Department of Columbia College Chicago from 1987 until her retirement in 2013. Blouin is a founding member of Sapphire & Crystals, a collective of Black women artists in Chicago, active since 1987, and a member of Black Women Photographers. Born and raised on the South Side, she enjoys love and life with her daughter, Kimaada, her son, Bakari, and granddaughter, Lotus Raine.